The Art of
OPTICAL
ILLUSIONS

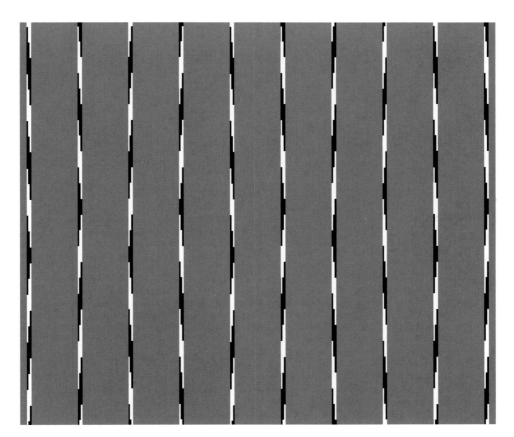

I humbly dedicate this book to my following colleagues and friends, who have provided me with so much inspiration and encouragement in the field of vision science.

Carol; Christof; Diana; Francis; Irving; Nick; Patrick; Pricilla; Rama; Ray; Richard; Roger; Shin; Stuart; Ted; Terry; Vicki

and especially to my cherished friend Paul and wife Alice without whom none of this would have been possible.

This is a Carlton Book

Text and illustrations © Illusion Works 2000
with the exception of the following:
Pages 32, 54, 74, 101, 141, 149 © 2000 Oscar Reutersvärd; page 33
© 2000 Jocelyn Faubert; page 20, 35 © 2000 Jerry Downs; pages 43,
130 © Bruno Ernst; page 67 © 2000 Peter Tse; pages 52, 112, 142 © 2000
Akiyoshi Kitaoka; pages 7, 47 © 2000 Monica Buch; page 51 © 2000 Ken
Knowlton; pages 10, 66 (bottom), 75, 81, 98, 108, 109, 137 © 2000 Roger
Shepard; pages 69, 71, 111, 118, 123, 132, 138, 143 © 2000 Sandro Del
Prete; page 76 © 2000 Támas Farkas; pages 91, 135, 157 © Nicholas
Wade; page 102 © René Magritte; page 17, 85 © 2000 Jos De Mey;
pages 18, 145 © 2000 Jerry Andrus.

Design copyright © Carlton Books Limited

3 5 7 9 10 8 6 4 2

A CIP catalogue for this book is available from the British Library.

US ISBN 1 84222 054 3

Project Editor: Vanessa Daubney
Project Art Direction: Paul Oakley
Production: Lisa French

Printed and bound in Dubai

ILLUSION WORKS

The World's Premier Optical Illusion Art Brand

IllusionWorks, L.L.C. is the World's Premier Optical Illusion Art Brand.
Please visit our award-winning website (www.illusionworks.com),
which feature all sorts of dynamic and interactive illusions, illusory
artwork, and in-depth scientific explanations.

For information on the illusions on page 1 and 3, please see
pages 38 and 73.

Thiery's Figure (page 7): The figure flip-flops because of contradictory
depth cues. Dutch artist Monika Buch created this version of Thiery's
illusory flip-flop illusion.

The Art of
OPTICAL
ILLUSIONS

Al Seckel

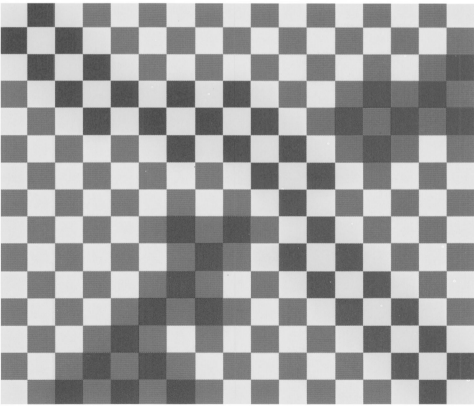

CARLTON
BOOKS

CONTENTS

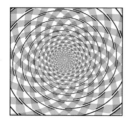

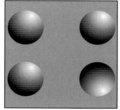

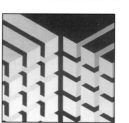

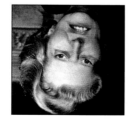

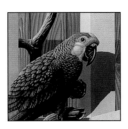

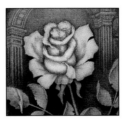

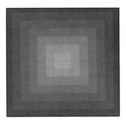

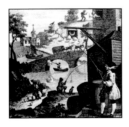

INTRODUCTION

"Whilst part of what we perceive comes through our senses from the object before us, another part (and it may be the larger part) always comes out of our own mind."
William James

Most of us take vision for granted. We seem to do it so effortlessly; however, perceiving images, objects, depth, and motion is a very complicated process. Only in the last one hundred years, and especially in the last twenty years, have scientists started to make some progress in understanding vision and perception.

Take a moment to observe the world around you. For example, if you tilt your head, the world doesn't tilt. If you shut one eye, you don't immediately lose depth perception. Look at what happens to colour under varying types of illumination. Move around an object: the shape you see changes, yet the object remains constant in your perception.

"Sorting it out" is a truly wonderful process; however, this process mainly happens in your brain and not in your eye! Light waves project into your eyes and then enter photoreceptive cells on your retinae. These retinal images, whether from a two-dimensional image or from our three-dimensional world, become semi-flat representations on a curved surface. Because of this, there is an innate ambiguity in your retinal input. For any given retinal image, there is an infinite variety of possible three-dimensional situations that could have projected the same image. Your visual system, however, usually settles for the correct interpretation. That is what your brain does – it interprets! And there are some very powerful constraints on just how your brain does this. Furthermore, your visual system needs to compute the "answer" quickly.

For the most part, these constraints work. You do not see many illusions in the real world, because your visual system has evolved so many different ways to resolve ambiguity. Many of these ways exploit the regularities of the world in which we live. Visual perception is essentially an ambiguity-solving process. However, mistakes can happen. Sometimes, an illusion occurs when there is not enough information in the image to resolve the ambiguity. For example, important clues that would normally be present in the real world, and which would have resolved the ambiguity, are missing.

Other illusions take place because an image violates a constraint based on an underlying regularity of our world. In other cases, illusions occur because two or more different constraints are in conflict. This means that your visual system can interpret the scene in more than one way. Even though the image on your retina remains constant, you never see an odd mixture of the two perceptions, although the two interpretations may perceptually flip back and forth.

Illusions are very useful tools for vision scientists, because they can reveal the hidden constraints of the perceptual system in a way that normal perception does not. Many of the illusions contained in this book will repeatedly fool your perceptions even though you know you are being tricked. This is because it is more important for your perceptual system to adhere to its constraints than to violate them simply because you have encountered something that is unusual, inconsistent, or paradoxical.

The illusions here have been divided randomly into four galleries. Many of them are not generally known, because they come out of the field of vision research. Of course, many of the classic illusions are also represented, but in almost all of these cases, we have strengthened or augmented their effect.

I have tried to provide a very brief scientific explanation of why many of these illusions work which can be found at the end of each gallery; however, in many cases, we still do not know the answer. This is especially true with most of the famous geometric illusions, such as the Poggendorf or Muller-Lyer illusions. Therefore it must be emphasised, the explanations in this book are tentative and should be regarded with some degree of scepticism, especially since some of the explanations involve my own speculations!

Vision science is one of the most exciting areas in current scientific research, and the study of illusions is one that brings great joy. I hope that this book will bring surprise and delight to both young and old alike, as well as stimulating some thought about the most marvelous mystery in the universe, the human brain.

Al Seckel
California Institute of Technology, 2000

Thiery's Figure: Examine the figure and it will appear to flip-flop (see page 2).

GALLERY

I

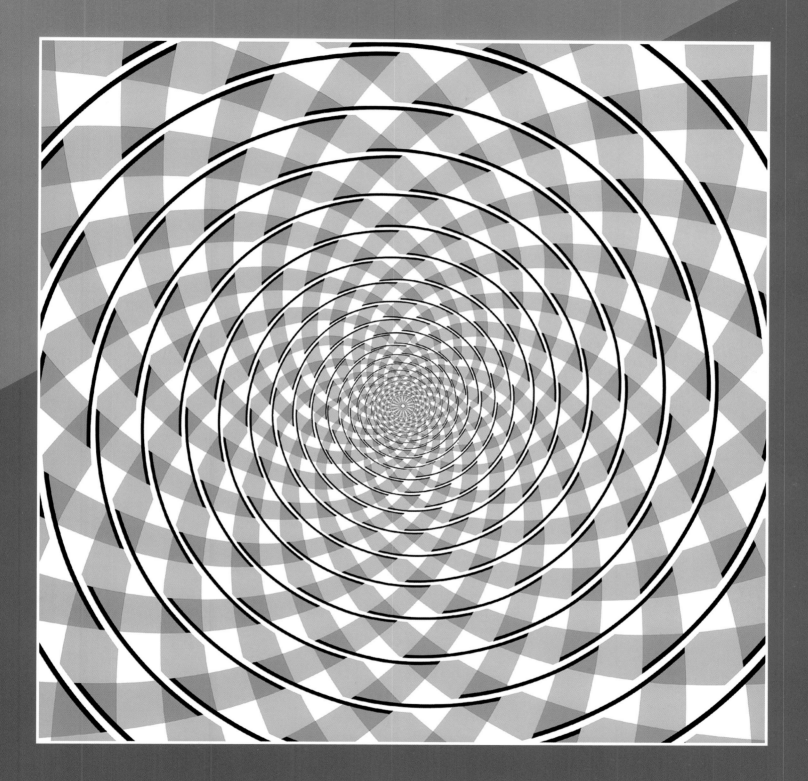

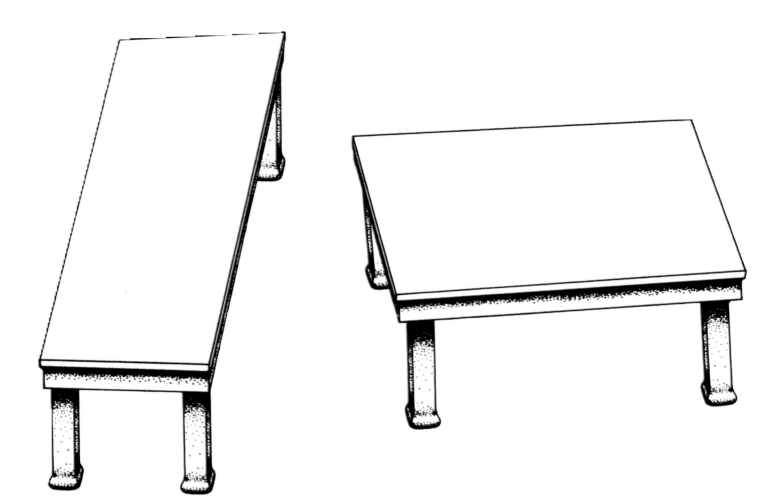

1 **Shepard's Tabletop:** The two tabletops are absolutely identical in size and shape! If you don't believe it, trace only the tabletops and see for yourself.

Previous page: **Fraser's Spiral** is one of the most powerful illusions known. What you see appears to be a spiral, but it is really a series of perfect concentric circles! This illusion is so powerful that it has been known to induce incorrect finger tracing!

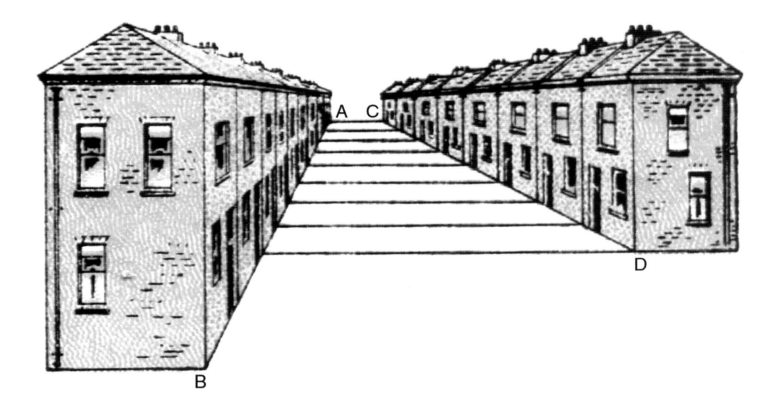

2 **Extent and Perspective:** Although they appear to be dramatically different in length, lines AB and CD are equal.

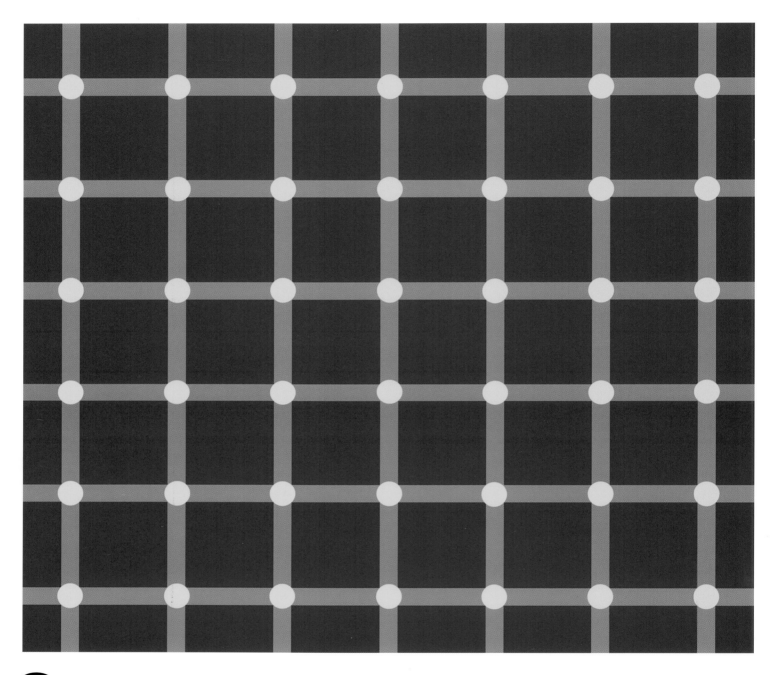

3 **The Scintillating Grid:** The disks at the junctions will appear to flash when you move your eyes around this image.

 Checker Shadow: The light check inside the shadow is identical to the dark check outside the shadow. If you don't believe it, cut out a peephole exactly the size of each square and test it!

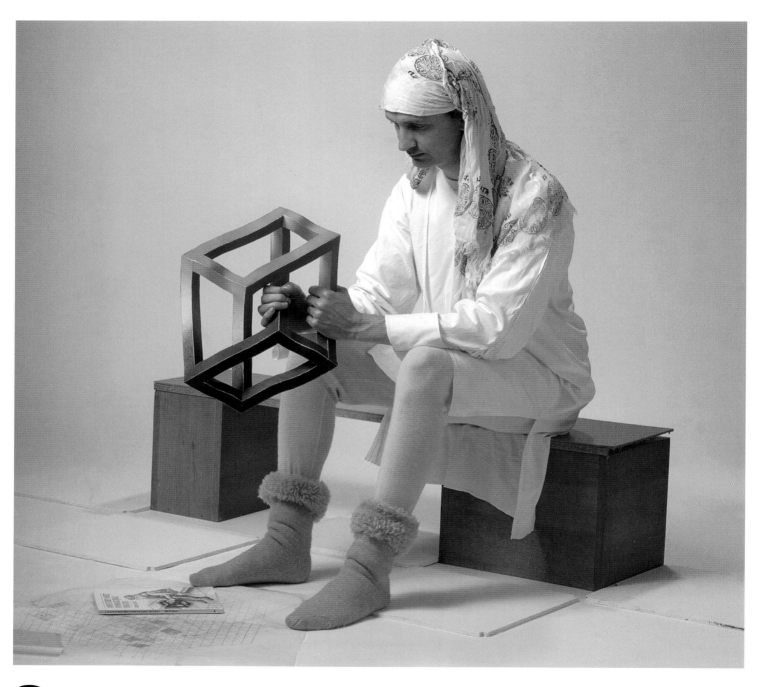

5 **Escher's Impossible Box**. Belgian artist Matheau Haemakers, drawing his inspiration from a print by the Dutch graphic artist M.C. Escher, has created a physical model of an impossible box.

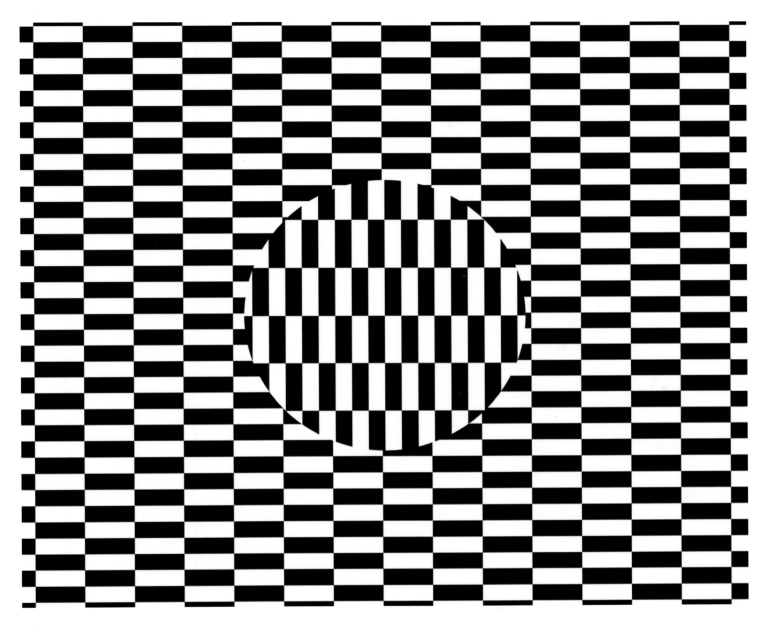

6 **Ouchi Illusion:** Move the page back and forth. The center section may appear to move in a direction different from its surroundings. The center section will also appear to be at a different depth.

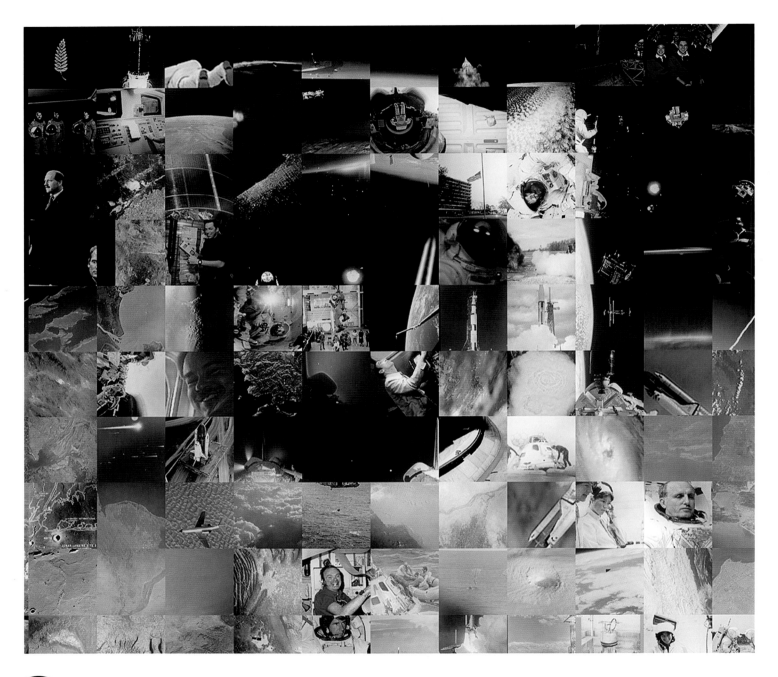

7 **Man on the Moon:** This image of Buzz Aldrin's helmet was made out of a collage of space images.

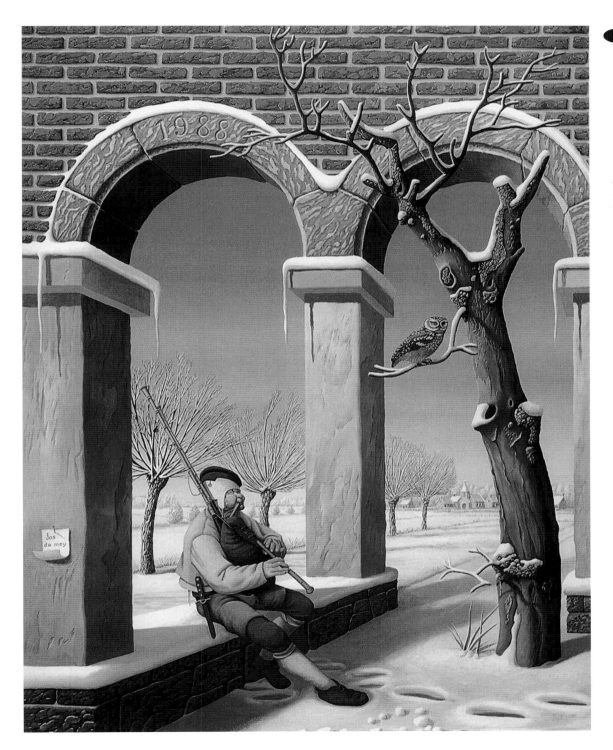

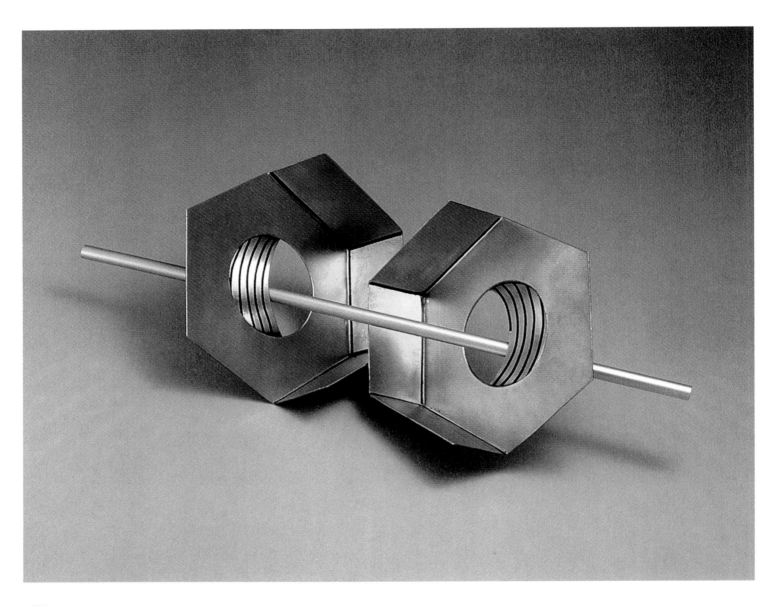

9 **Crazy Nuts:** Can you figure out how the
straight steel rod miraculously passes
through the seemingly perpendicular holes?

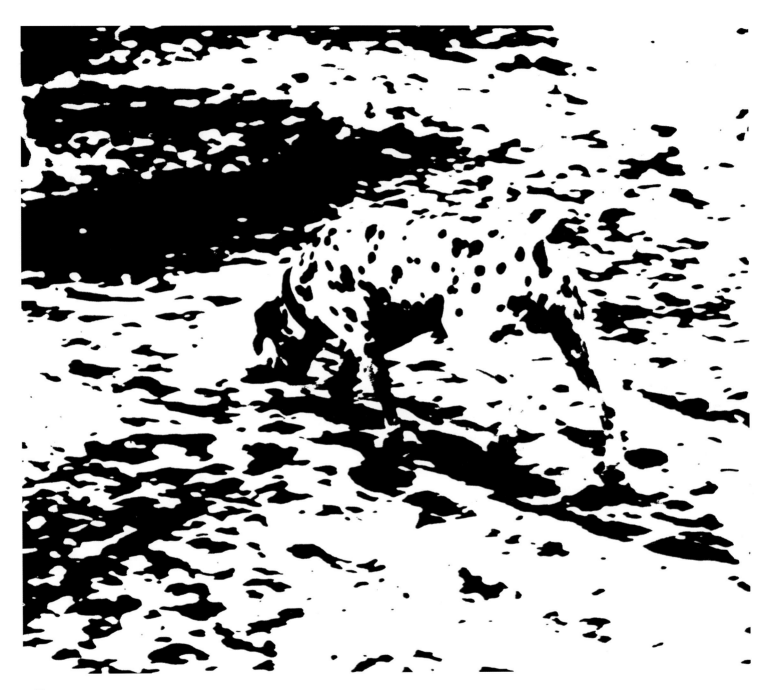

10 **Figure/Ground:** What is hiding here? Before you check out the answer, search carefully, because once you perceive the hidden image, you will never be able to see this image in its meaningless state again.

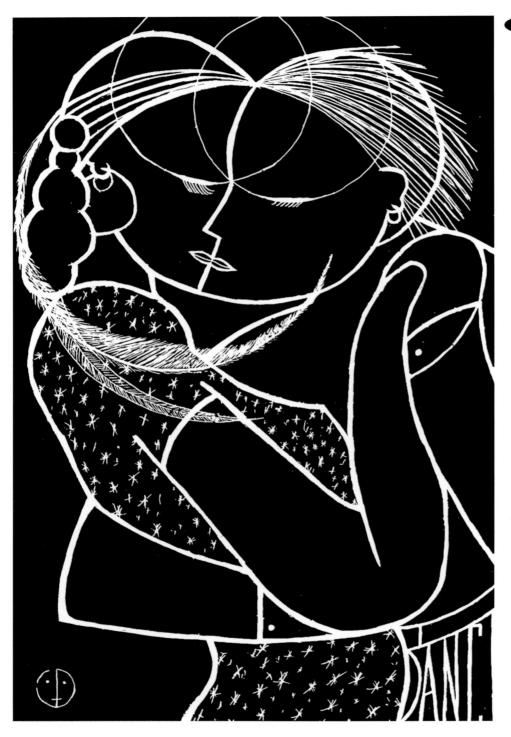

11 **Kissing Couple Illusion:** An illusory kiss by American artist Jerry Downs.

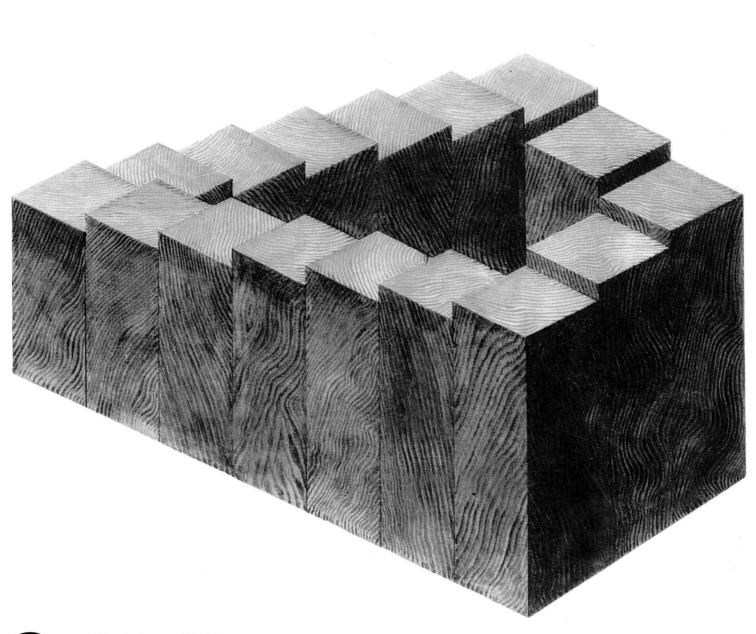

12 **Impossible Staircase:** What happens when you walk around this peculiar staircase? Where is the bottom or top step located?

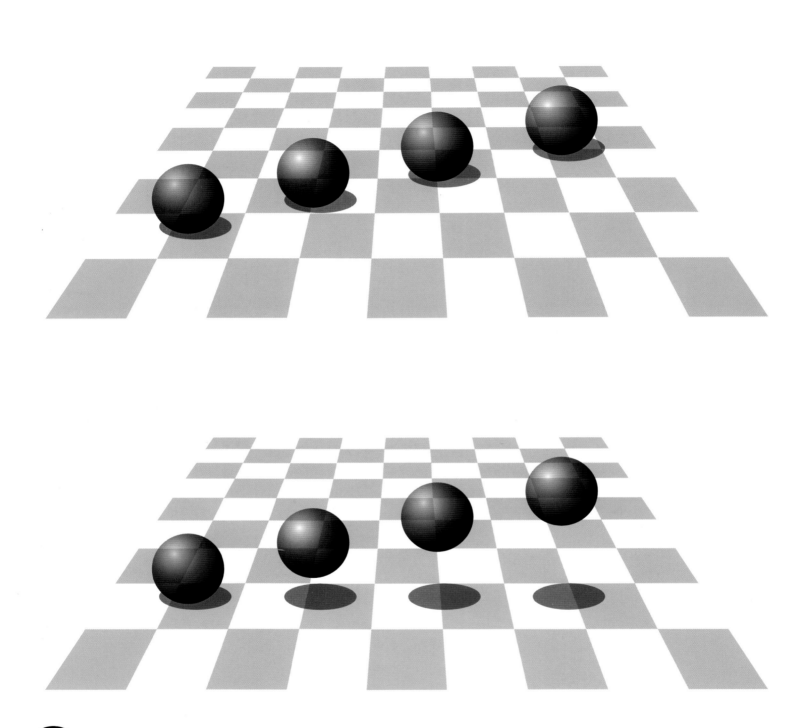

13 Ball and Shadow Illusion: *Are the balls in the two illustrations in different positions relative to the background?*

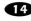 **Vanity:** Is there danger lurking for this couple?

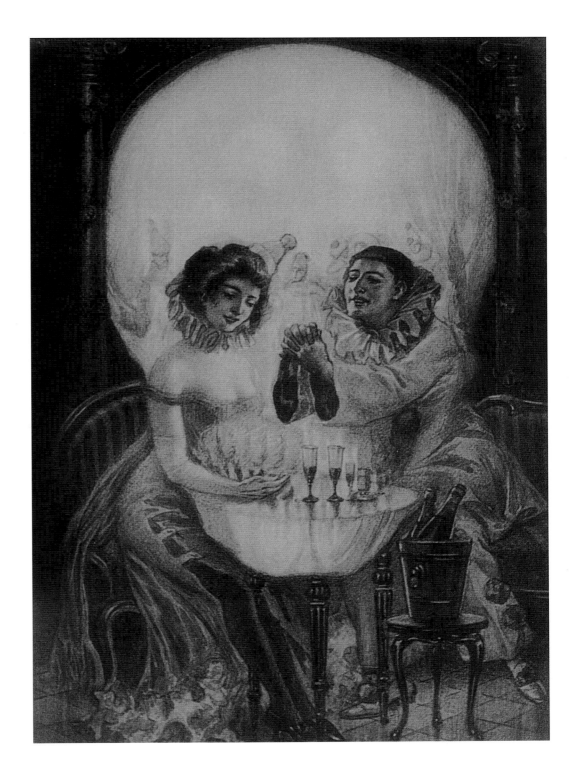

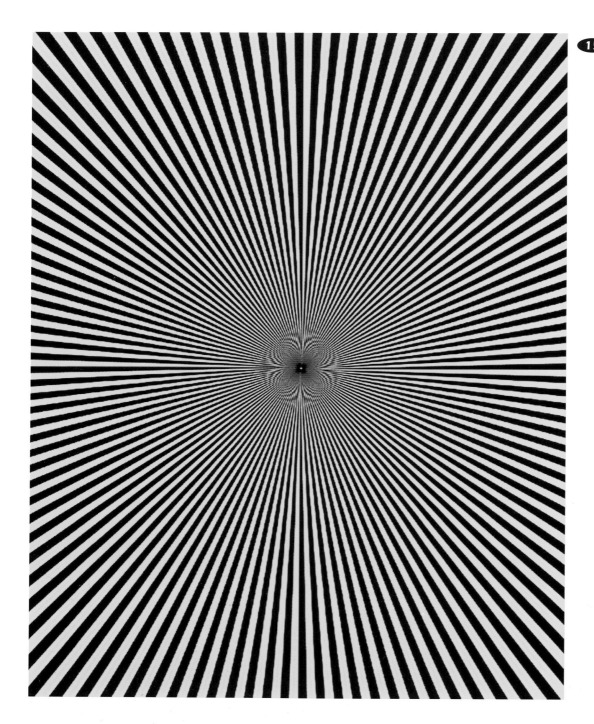

15 **Shimmer:** Move the page and you will perceive a shimmering swirl around the center. The colors are yellow and black, but you may see other colors as well.

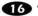 **The Hallway Illusion:** Is the small man standing in the foreground the same size as the man standing in the background?

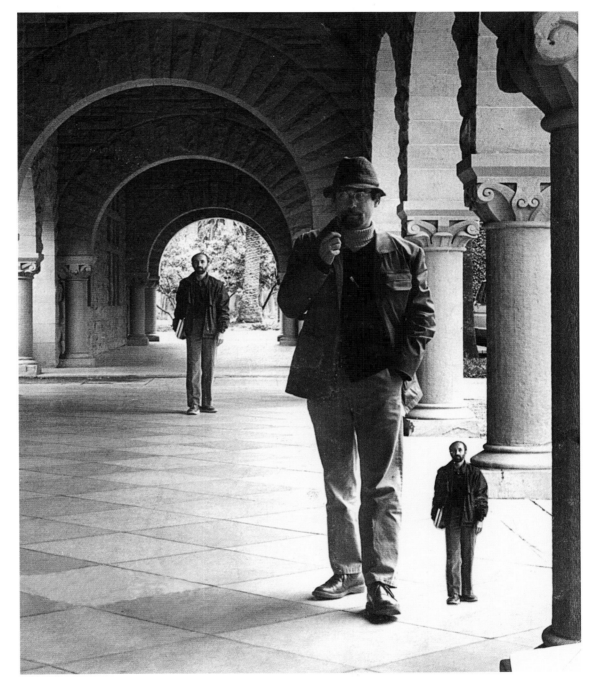

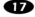 **Heart Afterimage:** Steadily fixate on
the black dot in the middle of the heart
for thirty seconds or more without moving
your eyes. Then quickly stare at a blank
sheet of white or gray paper. You will see
a beautiful red heart.

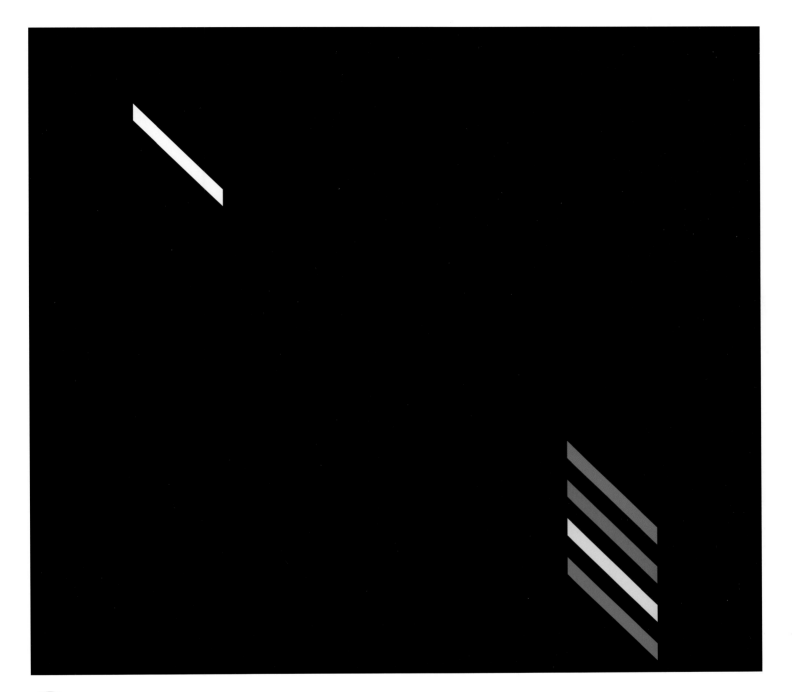

18 **Poggendorf Illusion:** What colored line is co-linear with the white line?

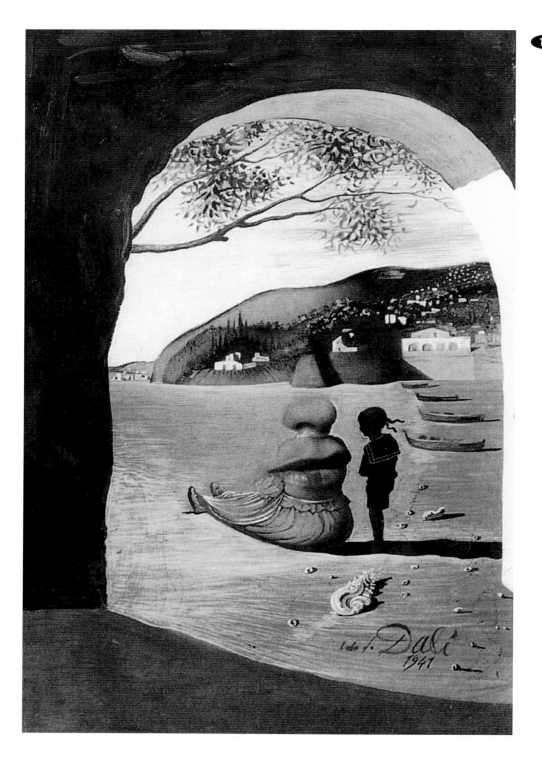

19 **"The Mysterious Lips that Appeared on the Back of my Nurse.":** The great Spanish surrealist painter Salvador Dalí entitled this work, "The Mysterious Lips that Appeared on the Back of my Nurse."

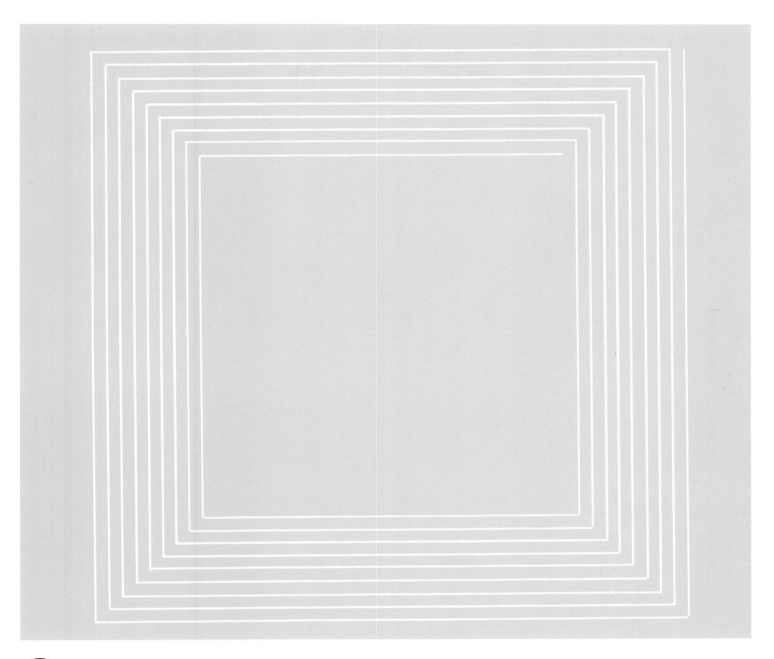

20 **Continuous Line Illusion:** These squares may look perfect and separated, but they are formed by one continuous line.

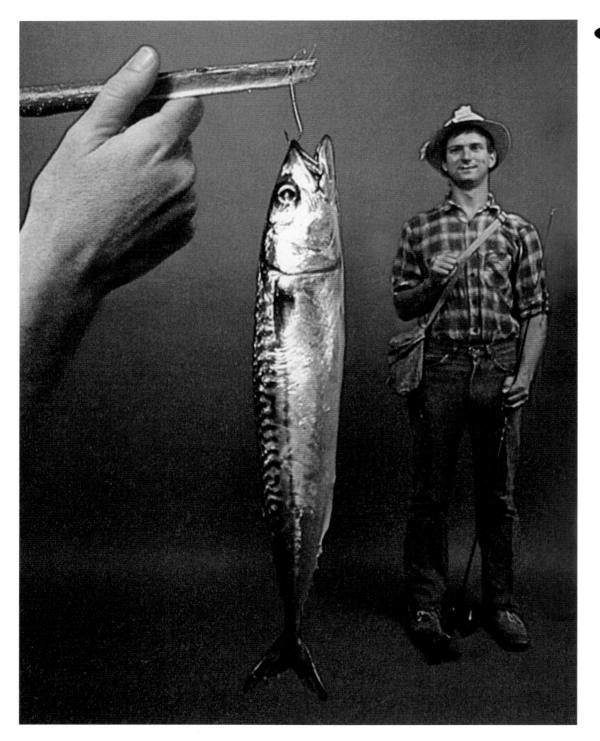

 Context Size Illusion: Cover the man and the fish appears to be a normal size. Cover the hand and the fish is a rather remarkable catch.

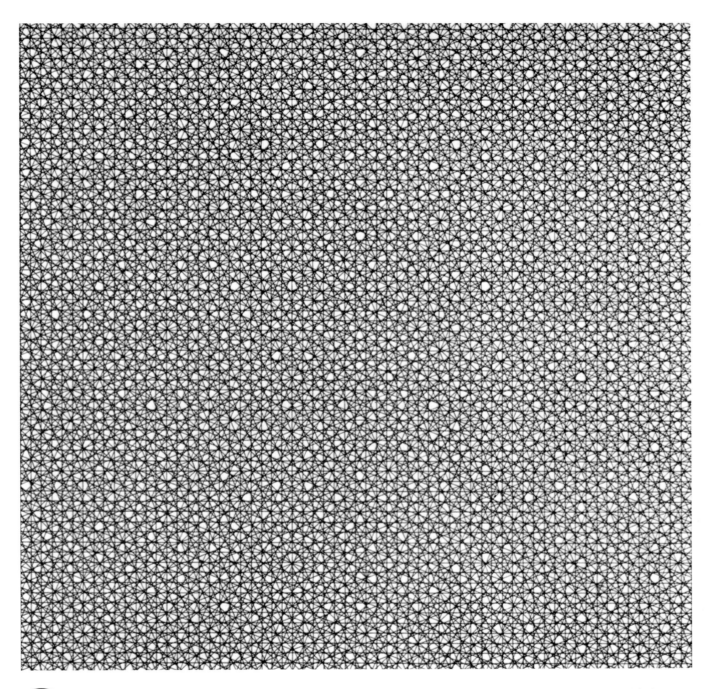

22 **Morellet's Tirets Illusion:** Move your eyes around this image and small circles will appear to scintillate and fade.

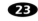 **Reutersvärd's Impossible Triangle:**
Here is an interesting version of the
impossible triangle by Swedish artist Oscar
Reutersvärd.

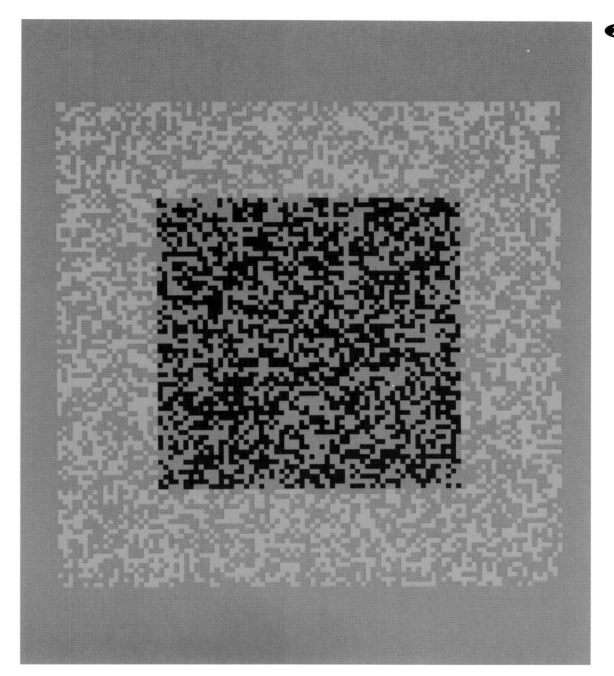

24 **Color Depth Illusion:** Stare at this figure for a while and the green area will appear to separate in depth. Tilting the page and viewing the image from above seems to help facilitate viewing this illusion.

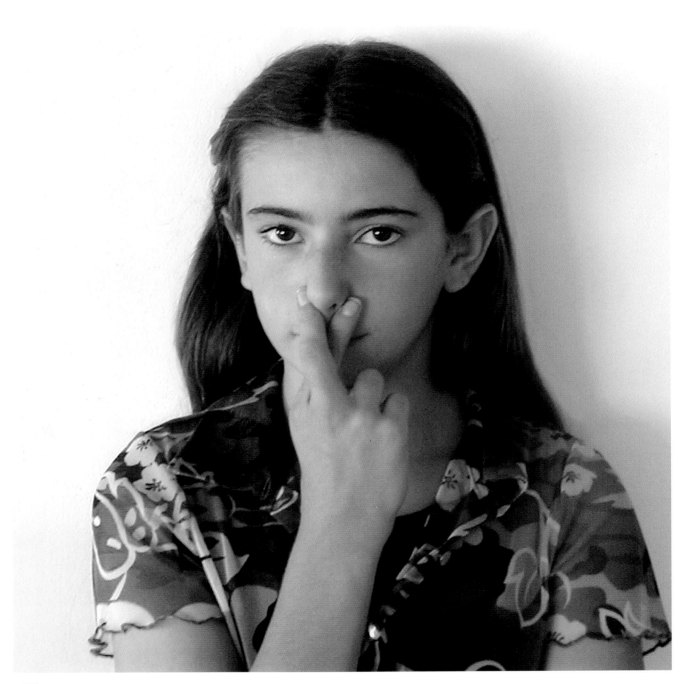

25 **Aristotle's Illusion:** *Aristotle's illusion is a most peculiar tactile illusion. Try crossing the first and second fingers of one hand. If the nose is rubbed gently with the inner surfaces of the crossed fingers – which are normally their outer edges – one may experience two noses!*

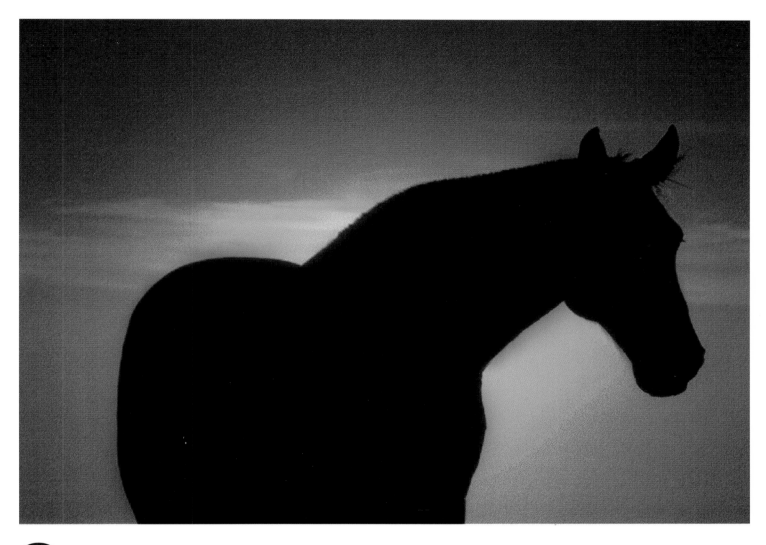

26 **Ambiguous Horse Illusion:** Which way is the horse facing? Jerry Downs created this photo illusion.

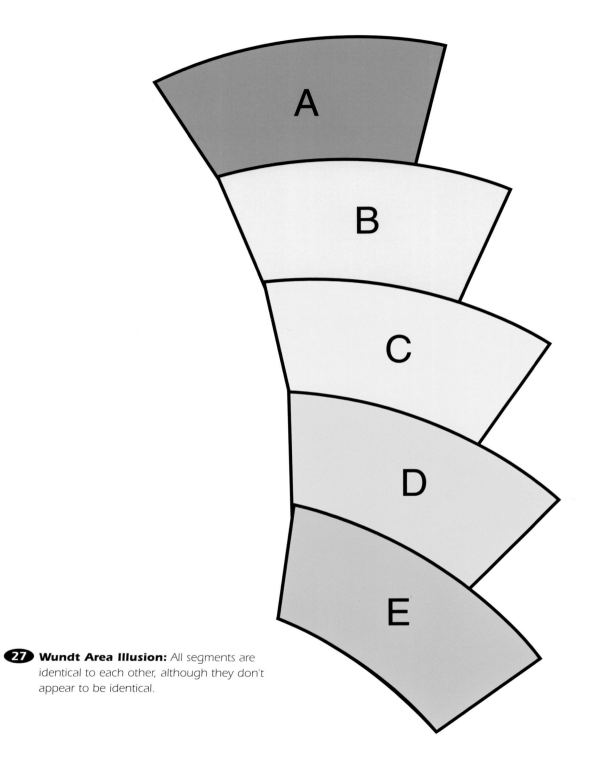

27 **Wundt Area Illusion:** *All segments are identical to each other, although they don't appear to be identical.*

1000
20
30
1000
1030
1000
+ 20

28 **Priming Illusion:** This is a wonderful priming illusion involving simple addition that will sometimes fool bank tellers and mathematicians. Add up the row of numbers out loud in groups. What is your answer? Do it again. Most people get the wrong answer! Try it on your friends for hilarious results. Only look at the correct answer after you have tried it.

29 **Stereo Line Illusion:** Hold the illustration so that it is just below both eyes and that the image lies flat and perpendicular to your face. Look at the two lines with both eyes and after a while a third line will appear to rise out of the page.

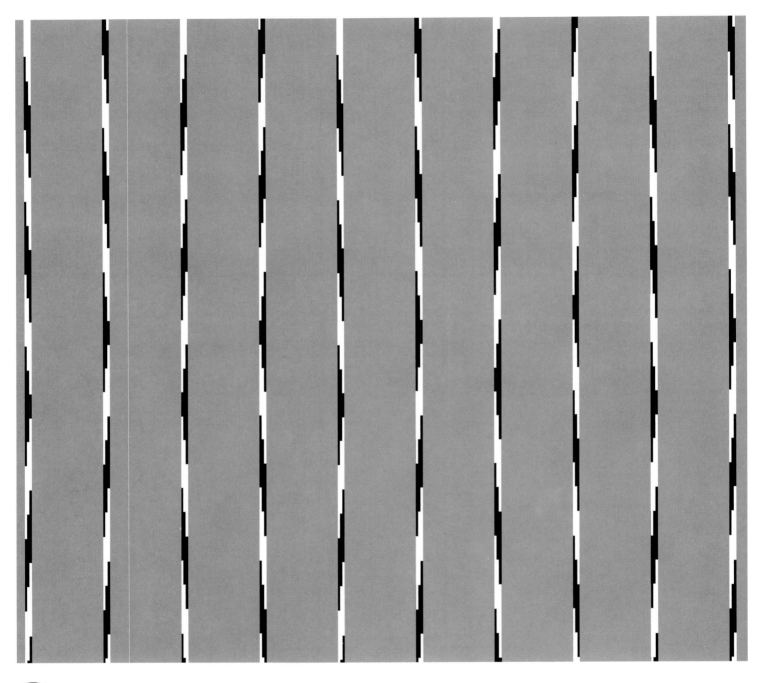

30 **Twisted Cord Illusion:** The vertical lines appear to bend, although they are all perfectly straight and parallel to each other.

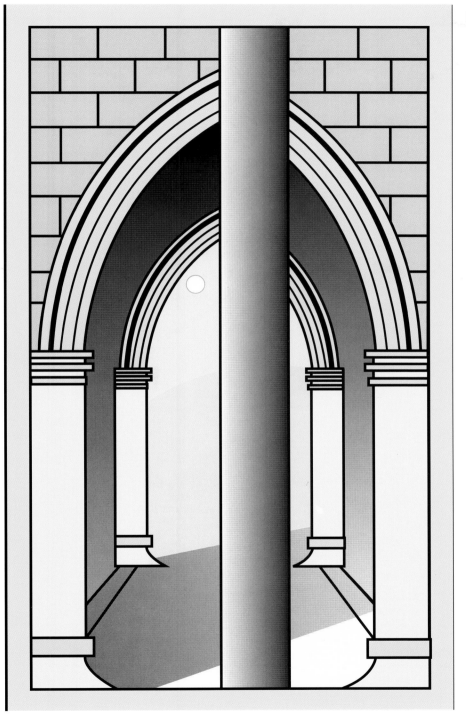

31 **Poggendorf Illusion with Pillars:** Are the arches in back of the pillar built incorrectly? Or is the pillar causing an illusion?

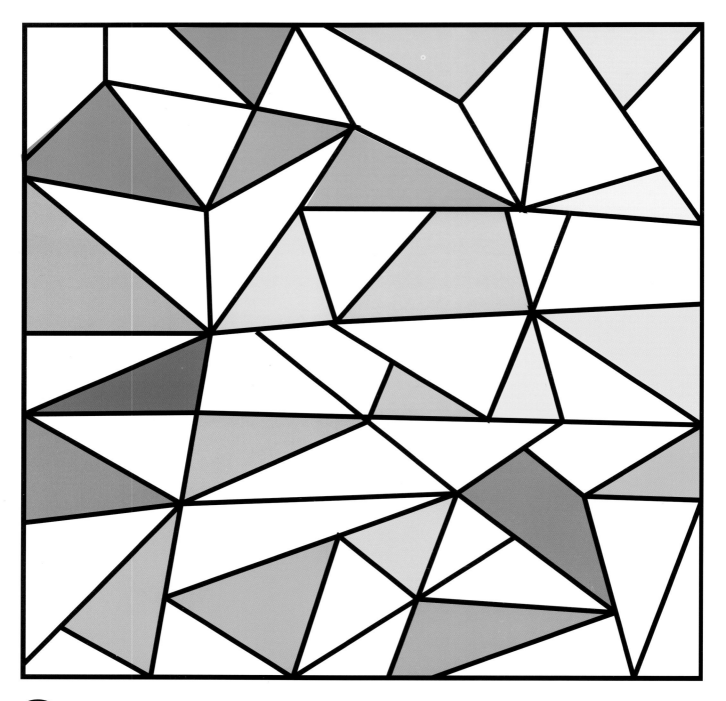

32 **Find the Hidden Star:** Can you find the five-pointed star hidden in the pattern. Search carefully before you seek the answer.

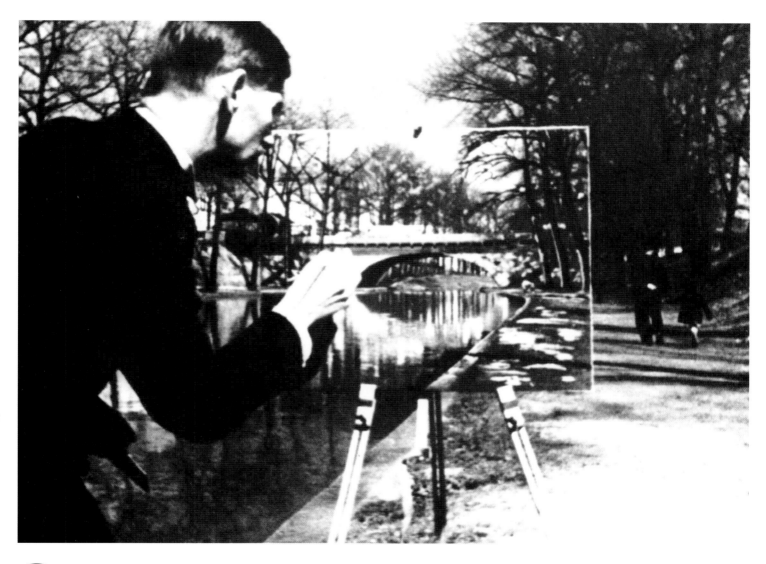

33 **This is not a Magritte:**
This photographer caught an unusual
painting by an artist.

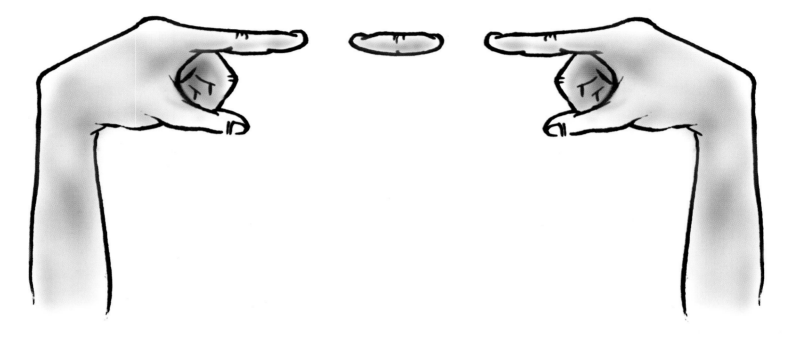

34 **Floating Finger Illusion:** You can make a finger float right before your eyes in this fun illusion. Hold your two hands in front of your face at eye level. Keep the tips of your index fingers also at eye level. Focus on a wall several feet behind your fingers. You should see a finger float. Try moving your fingers closer to your face. What happens? If you focus on your fingers, instead of the wall, the illusion vanishes.

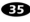 **35** **Physical Model of an Impossible Triangle:** This triangle is possible in the mirror, but impossible as seen outside the mirror. How can that be?

Notes on Gallery I

Fraser's Spiral (Page 9)
The perceived "twist" at each portion of the circle is transmitted across the entire circle to produce the spiral effect. Cover half of the illustration and the illusion will no longer work. English psychologist James Fraser created a whole series of these twisted cord illusions in 1906.

1. Shepard's Tabletop
Although the drawing is flat, it suggests a three-dimensional object. The table's edges and legs provide perspective cues that influence your interpretation of its three-dimensional shape and constancy. This powerful illusion clearly demonstrates that your brain does not take a literal interpretation of what it sees. Stanford psychologist Roger Shepard created this illusion.

2. Extent and Perspective
Again, perspective cues provide a three-dimensional context for perceiving length.

3. The Scintillating Grid
German vision scientists Michael Schrauf and E. R. Wist discovered the Scintillating Grid illusion in 1997. It is not yet fully understood what causes this effect.

4. Checker Shadow
The light check does not look dark because your visual system interprets the darkness as belonging to the shadow and not to the check. MIT vision scientist Ted Adelson recently designed this incredible brightness illusion.

6. Ouchi Illusion
The intersections between the vertical texture and the horizontal texture seem to trigger your visual system's motion detectors in different ways. When the page is moved back and forth you will perceive illusory motion in depth. It was discovered in 1977 by the Japanese op-artist Hajime Ouchi.

9. Crazy Nuts
The nuts are actually hollow, but appear to be convex, so the holes are not perpendicular to each other. The Crazy Nuts have been lit from below (normally light comes from above), which gives incorrect information about their true three-dimensional shape. American magician Jerry Andrus created this wonderful illusion.

10. Figure/Ground
It is a Dalmatian dog. Once you perceive the dog, the picture becomes dramatically reorganized with certain parts of the dots being grouped with the dog and others with the background. This illustrates the importance of prior experience on visual perception, especially if the organization and meaning of the image is highly ambiguous. Once your visual system ascribes meaning to a particular image, the meaningful interpretation dominates. This is also an example of a non-reversible figure/ground illusion.

12. Impossible Staircase
There is no bottom or top staircase. That is why it is impossible. The impossible staircase, first created by geneticist Lionel Penrose in the mid 1950s, served as inspiration for M. C. Escher's classic print, "Ascending and Descending."

13. Ball and Shadow Illusion
In the top illustration, the balls appear to be resting on the surface and receding into the distance. In the bottom illustration, the balls appear to be rising above the surface and not receding. The only difference between the two illustrations is the placement of the cast shadows, which provide a context for interpreting the three-dimensional position of the ball relative to the background. Without a shadow the position of the balls is ambiguous. Vision scientists Dan Kersten and David Knill first described this effect in 1996.

14. Vanity
The meaning of this image will flip-flop between a skull and a couple sitting at a table. This 1920s French postcard featuring a skull or two lovers became a popular motif throughout the 20th century inspiring such artists as Salvador Dalí.

15. Shimmer
It is not fully understood what causes this illusion.

16. The Hallway Illusion
The very small man standing in the bottom right of the passageway is the same man from the background who has been digitally copied to the foreground. There is no difference in size, except that he is placed further away from the horizon. Perspective information also gives the strong impression of depth in a receding corridor. As an object recedes into the distance against a perspective background, not only does its visual angle become smaller, but it also moves closer to the visual horizon. This illusion is similar in some ways to the Ponzo illusion.

17. Heart Afterimage
The color receptors in your eye actually work in pairs: red/green and blue/yellow. When the red receptors become fatigued the green receptor will dominate and vice versa. This is known as a color afterimage.

18. Poggendorf illusion
The yellow line is co-linear with the white line. This is a powerful variant of the classic 19th century Poggendorf illusion. There are many theories about why this simple geometrical illusion occurs, but none proposed to date gives a satisfactory account for all the conditions under which it diminishes or appears. One possibility is that your visual system is extremely poor at interpreting the path of diagonal lines, although it not understood why.

20. Continuous Line Illusion
Although this illusion is not well understood, we do know that your visual system is extremely poor at curve-tracing. Your eye cannot determine the relative placement of fine lines without tracing them, and even then performs this task very poorly.

21. Context Size Illusion
What you perceive sometimes is dependent upon context. Irvin Rock developed this context size illusion.

22. Morellet's Tirets Illusion
Your visual system tends to prefer organization and groups, so it searches for the "best" interpretation. In most images there is a way to group and organize the image. However, in this painting "Tirets" by French artist Francois Morellet, there is no "best" interpretation. Rather, there are lots of possible circles. As you scan this image, your visual system is constantly searching for the "best" interpretation; however, many continuously arise.

24. Color Depth Illusion
Canadian vision researcher Jocelyn Faubert discovered this new color depth illusion.

25. Aristotle's Illusion
You are used to feeling the left side of an object with your left finger and the right side of an object with your right finger. When you cross your fingers your motor system and your tactile system give conflicting information about what is where, sometimes resulting in the experience of a second nose.

27. Wundt Area Illusion
Although this classic illusion was discovered over 100 years ago, it is still not fully understood.

28. Priming Illusion
The correct answer is 4100.

29. Stereo Line Illusion
This particular viewpoint causes the image in each eye to fuse together; resulting in a third line that appears in stereo.

30. Twisted Cord Illusion
This illusion happens early on in the visual system, when your retinae encodes edges and contours. It is known as a twisted cord illusion.

31. Poggendorf Illusion with Pillars
There is nothing wrong with the arches. This illusion is a variation on the classic Poggendorf illusion.

32. Find the Hidden Star
Look in the bottom right region. The puzzle is difficult because there are too many possible ways to group the lines. However, once the star has been pointed out, you will never be able to see it in its meaningless state again. The great American master of puzzles Sam Lloyd created this classic figure/ground puzzle.

34. Floating Finger Illusion
By focusing on the wall, the two fingers in the foreground incorrectly overlap when the images from both eyes are automatically combined. These overlapping images produce a stereogram with the floating finger.

35. Physical Model of an Impossible Triangle
This physical model of an impossible triangle only works from only one special angle. Its true construction is revealed in the mirror. Even when presented with the correct construction of the triangle (as seen in the mirror), your brain will not reject its seemingly impossible construction (seen outside the mirror). This illustrates that there is a split between your conception of something and your perception of something. Your conception is ok, but your perception is fooled.

36. Shape from Shading
Your brain uses clues to determine depth in a 2D picture. One clue is the shading. Normally, light comes from above. By turning the figure around, your brain receives clues that light is coming from another angle, and thus the same shading will correspond to another shape.

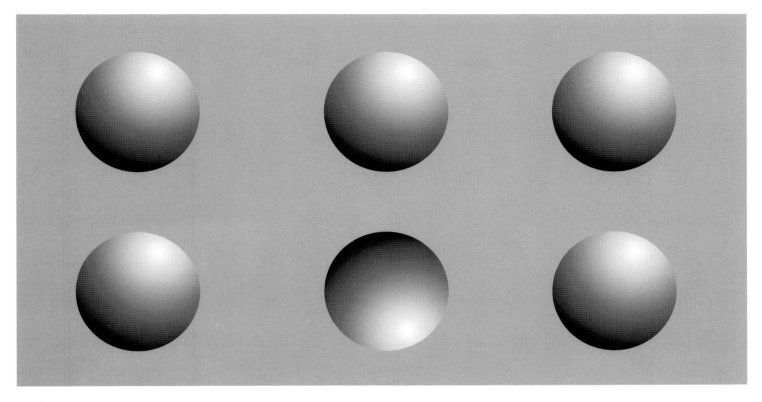

36 **Shape from Shading:** How many areas are concave? How many are convex? Turn the image upside-down and count again. Note that all the shapes change together.

GALLERY

II

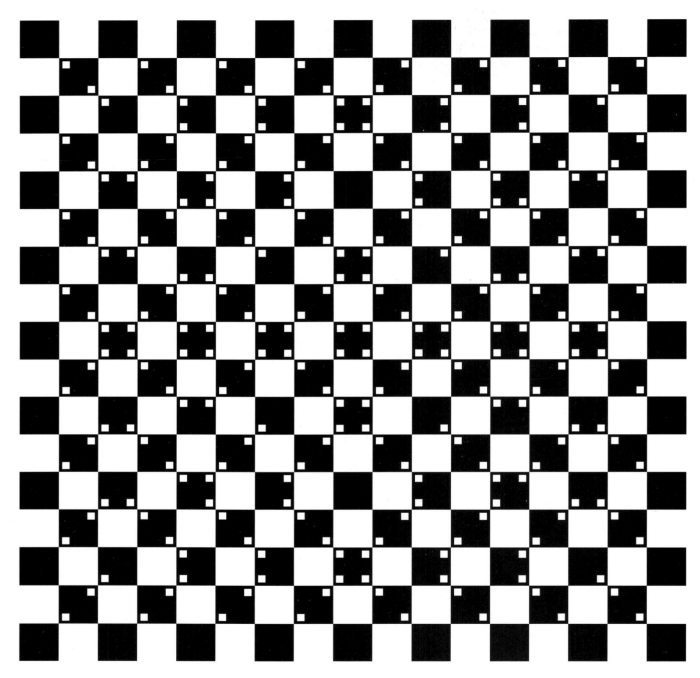

37 **Kitaoka's Waves:** *Are the lines all straight and parallel or are they bent?*

Previous page: **Monika's Cube:** This is a lovely reversible cube by Dutch artist Monika Buch.

 38 **Circular Poggendorf**
Illusion: Are the ends of the
two circular segments perfectly
aligned?

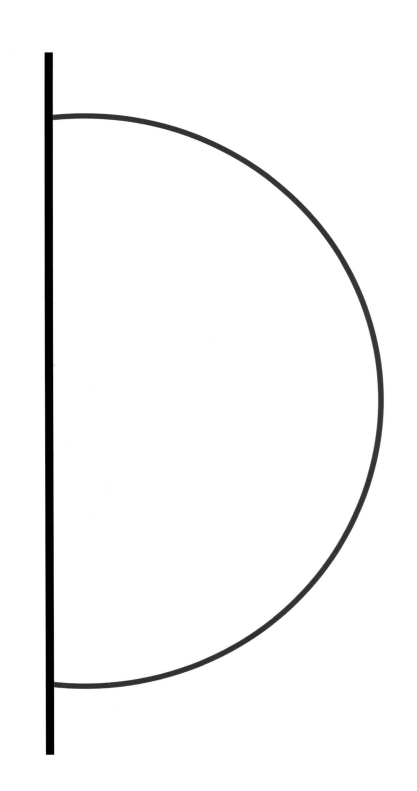

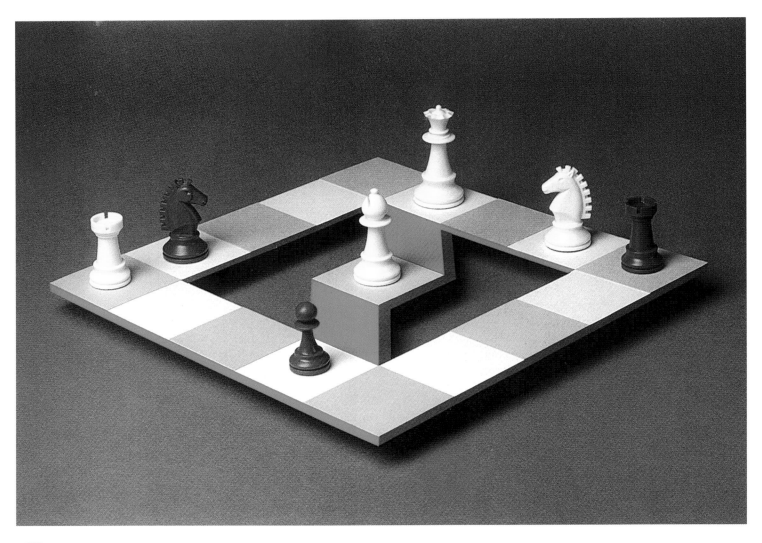

 Impossible Chess Set: How is this possible?

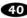 **40** **Einstein and the Sea:** *Artist Ken Knowlton creates portraits out of unusual objects. Here, Einstein is depicted using only seashells. The seashells are entirely natural and have not been painted over.*

41 **Twisted Cord with Squares:** Are these perfect squares?

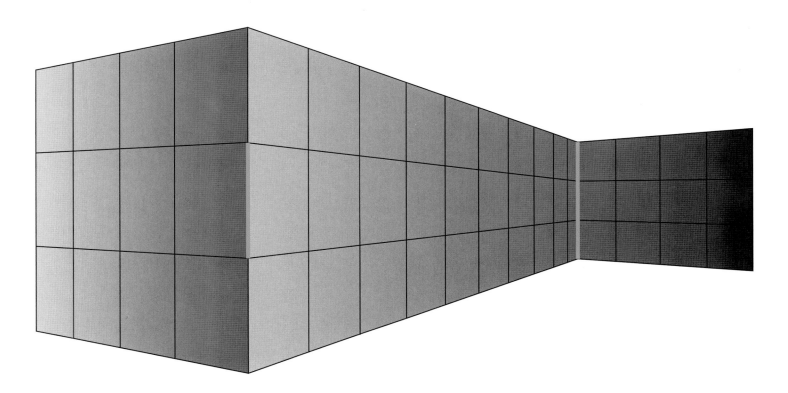

42 **The Müller-Lyer Illusion in Perspective:** *Which red line is longer?*

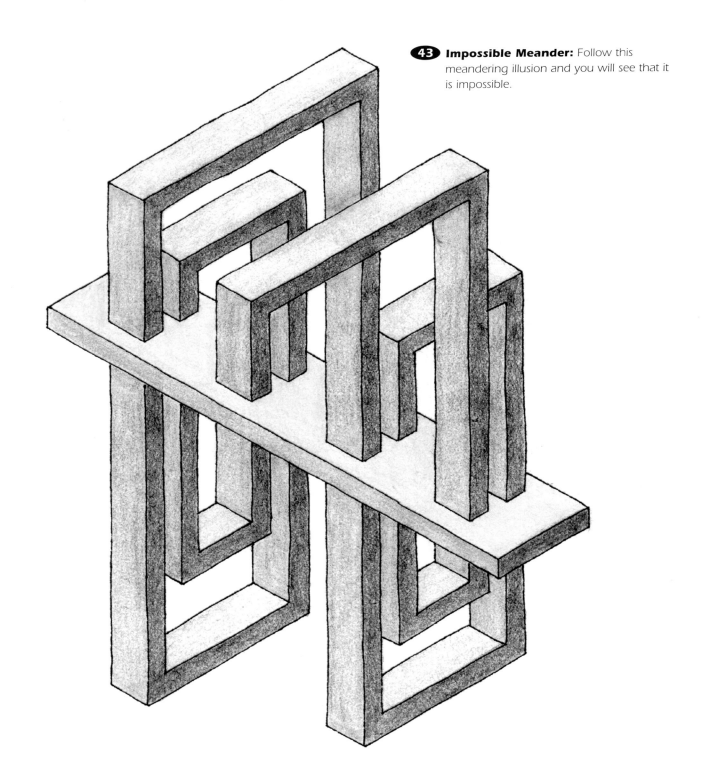

 Ten Children: There are five heads, but one can count ten children!

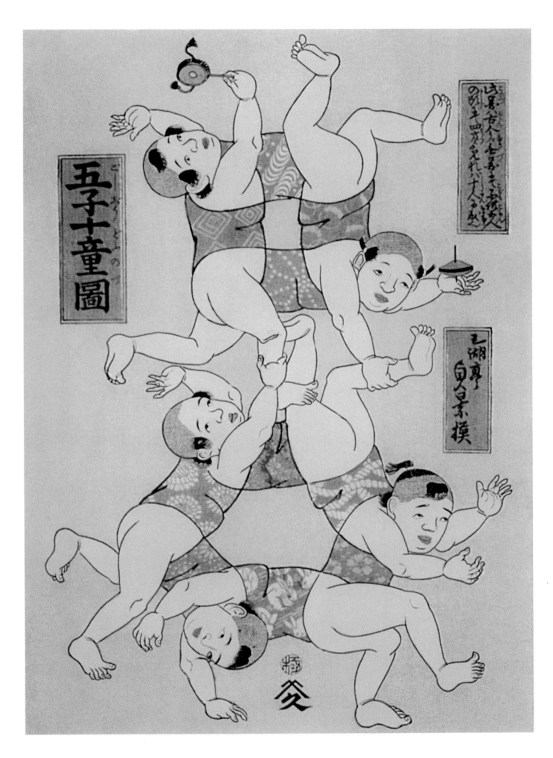

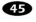

56

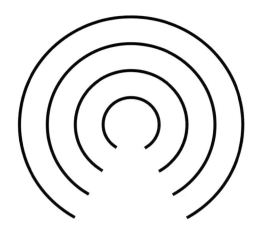

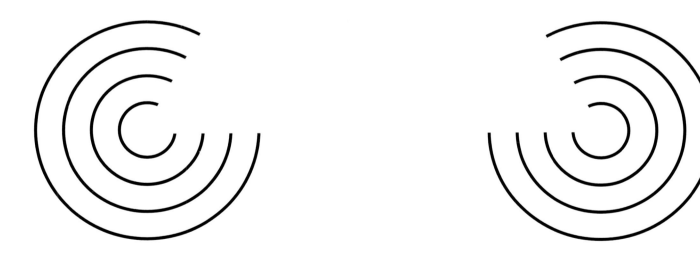

46 **Kaniza Triangle:** Do you perceive a white triangle even though there are no edges or contours? Does the triangle appear whiter than the white background?

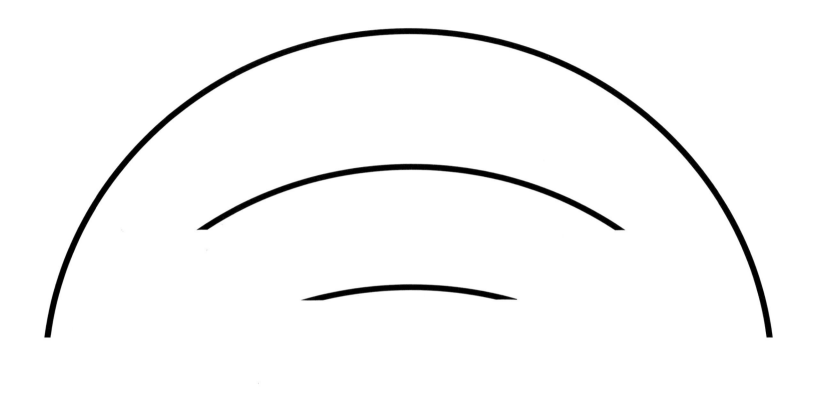

47 **Tolansky's Curvature Illusion:** *Which line segment has the greatest radius of curvature?*

48 **Jittering Square Illusion:** Do the squares look slightly tilted with respect to each other?

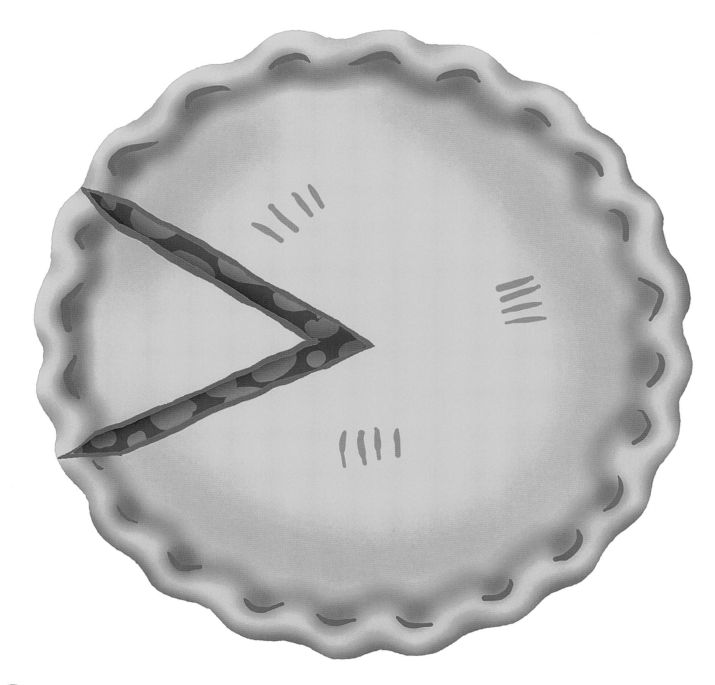

49 **Where's the pie?** This scrumptious pie has the amazing ability to appear and disappear right before your eyes! You can either see one piece of pie or the whole pie with a piece missing.

50 **Where's the midpoint?**

One of the arcs within
the circle passes through
the centre of the circle.
Which coloured line is it?
Without using a
measuring device
can you determine
the correct
coloured arc?

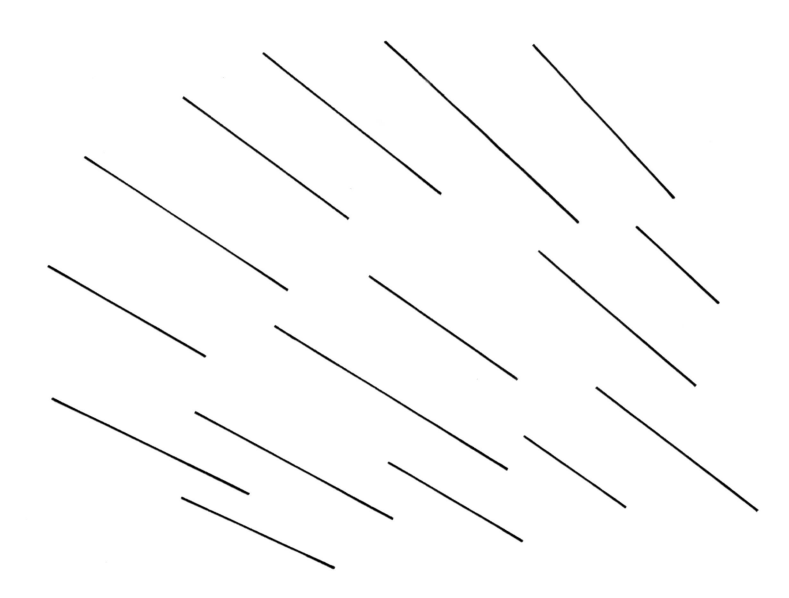

51 **Rising Line Illusion:** *Can you make these lines rise out of the page? Tilt the page and look at the image with one eye from the bottom right side of the page.*

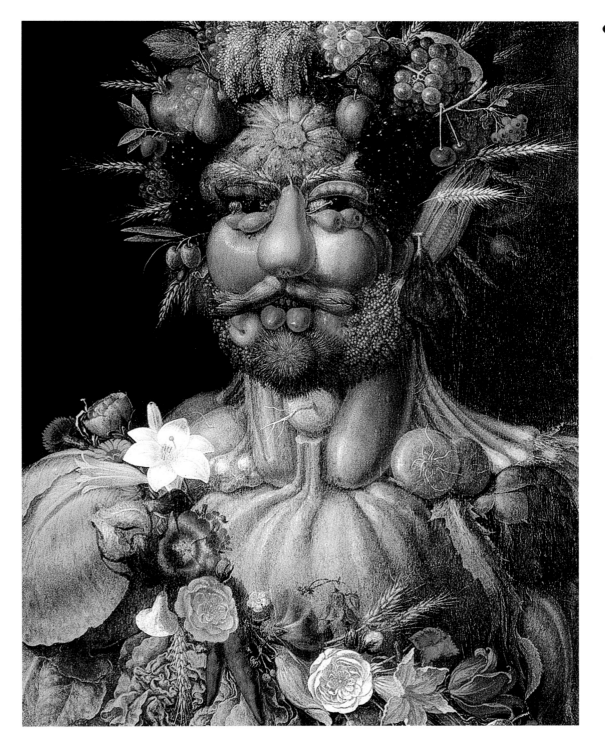

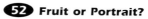 **Fruit or Portrait?**
Do you see a
collection of fruit or a
portrait of Emperor
Rudolph II?

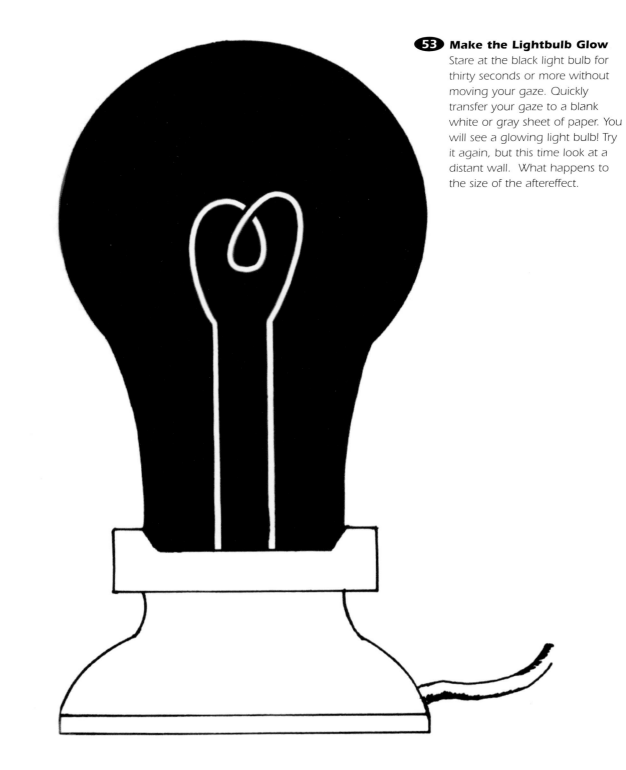

53 Make the Lightbulb Glow
Stare at the black light bulb for thirty seconds or more without moving your gaze. Quickly transfer your gaze to a blank white or gray sheet of paper. You will see a glowing light bulb! Try it again, but this time look at a distant wall. What happens to the size of the aftereffect.

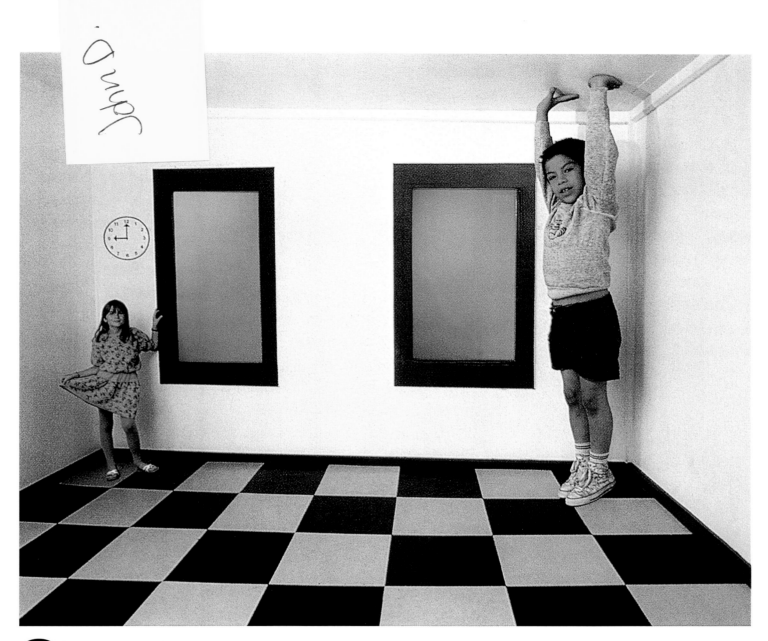

54 **Ames Room Illusion:** The two people in this room are exactly the same height!

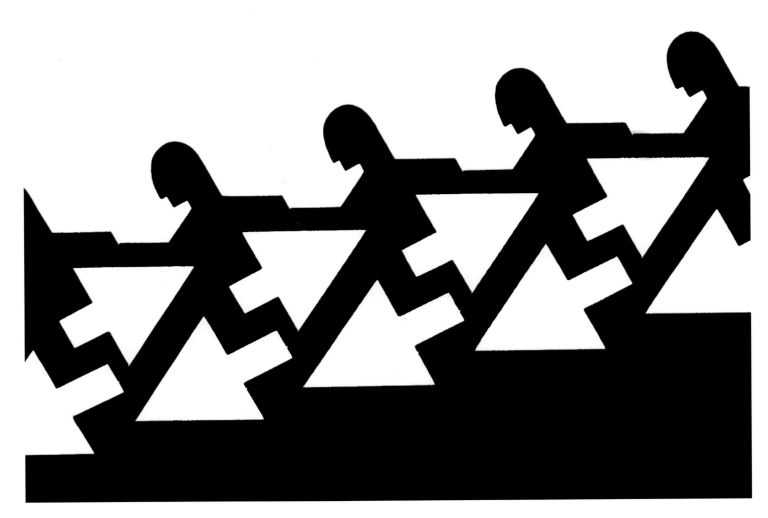

55 Camouflage: What do these strange symbols signify?

56 Time Saving Suggestion: A wonderful figure/ground illusion by Stanford psychologist Roger Shepard.

 Illusionary Sphere: Can you perceive a sphere even though there are no edges or shadows to define it?

58 **The Woman with Closed Eyes:** Stare at this woman and her eyes will suddenly open!

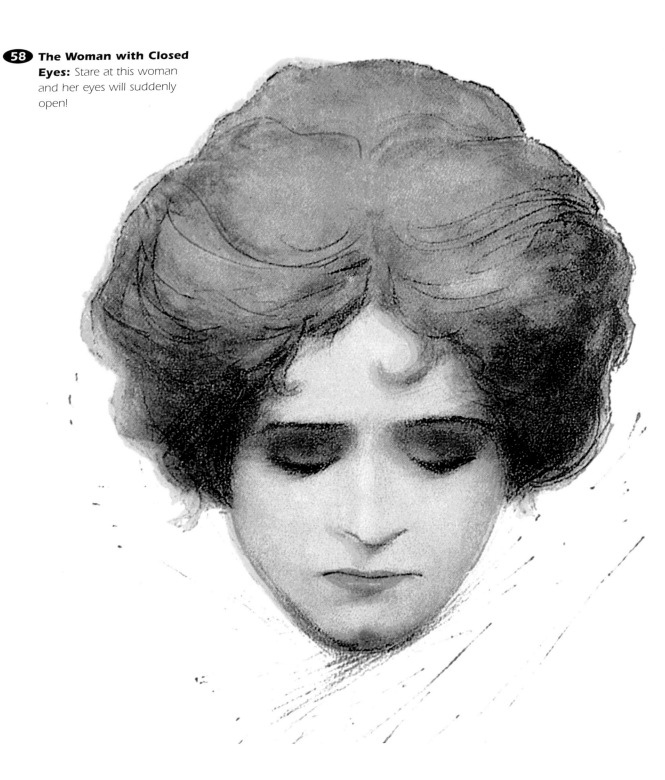

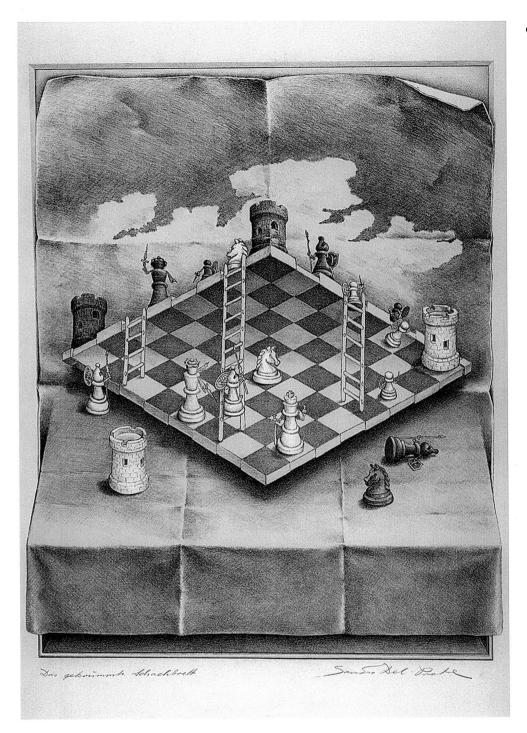

Das gekrümmte Schachbrett

Sandro Del-Prete

59 **Folded Chess Set:** Are you looking at this chessboard from the bottom or the top?

60 **Ponzo Illusion:** *Are the balls perfectly aligned?*

 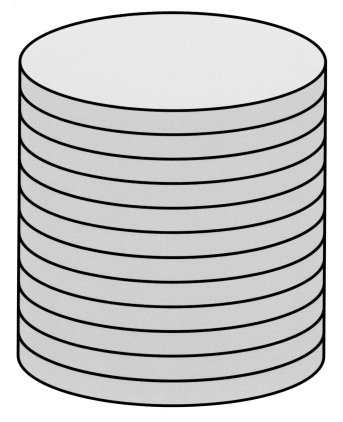

61 **Height/Breadth Illusion:** *Do the two stacks appear as high as they are broad?*

62 **Homage to Leonardo Da Vinci:** From where is Leonardo da Vinci obtaining his inspiration for his portrait of a mule and rider.

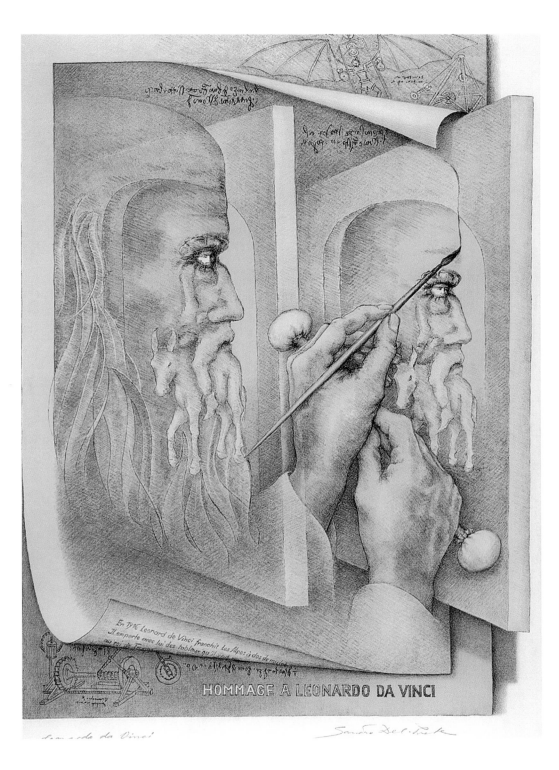

 Simultaneous Orientation Contrast: Do the vertical red lines in the two center sections look tilted with respect to their surrounds?

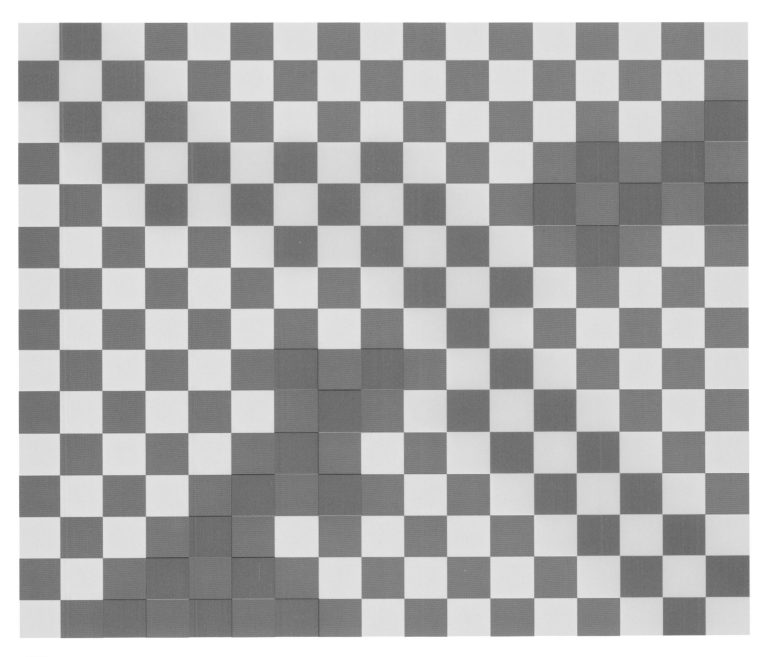

64 **Bezold Illusion:** Do all the reds appear the same?

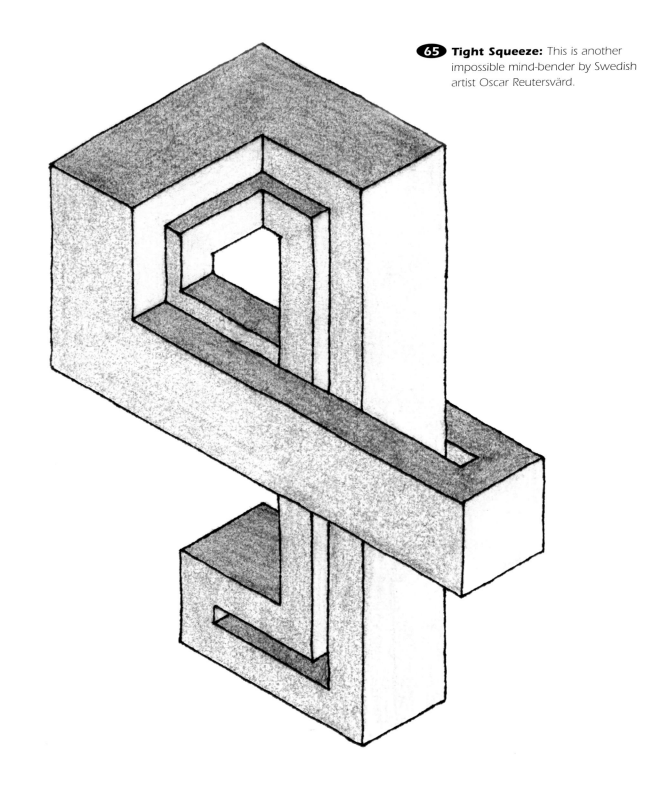

65 Tight Squeeze: This is another impossible mind-bender by Swedish artist Oscar Reutersvärd.

 Sara Nader: Can you find the woman's face?

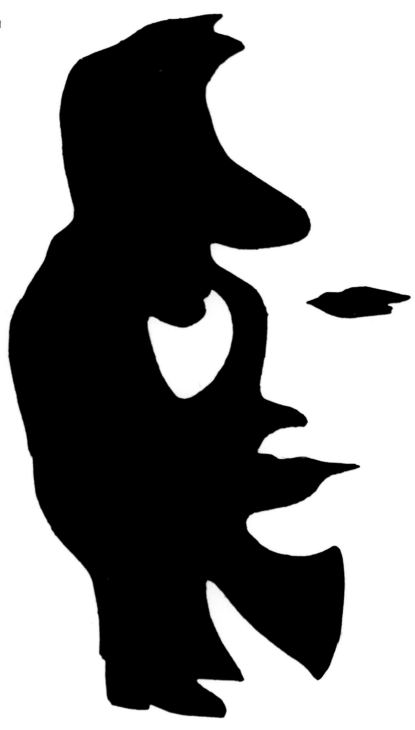

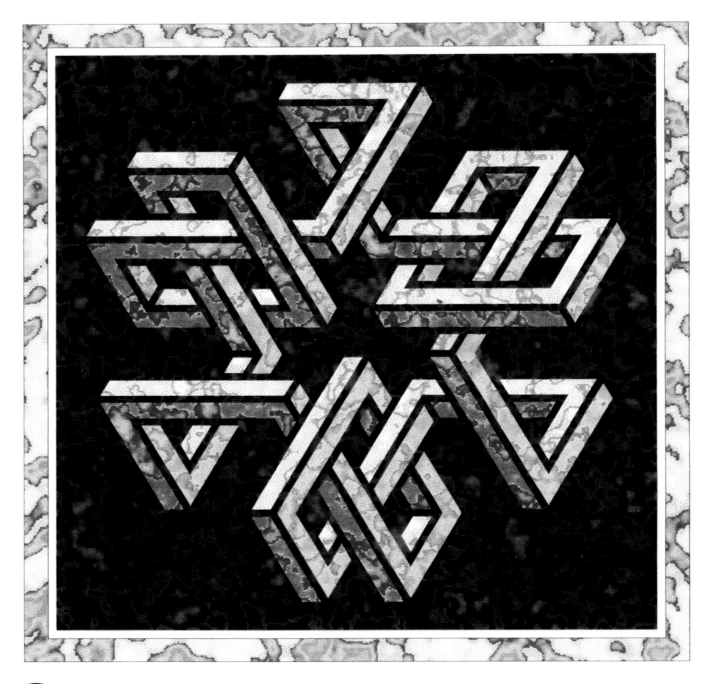

67 **Meandering Paradox:** This is a wonderful impossible meander by Hungarian artist Támas Farkas.

68 **Hidden Figure:** What do you see here? Try hard before looking at the answer.

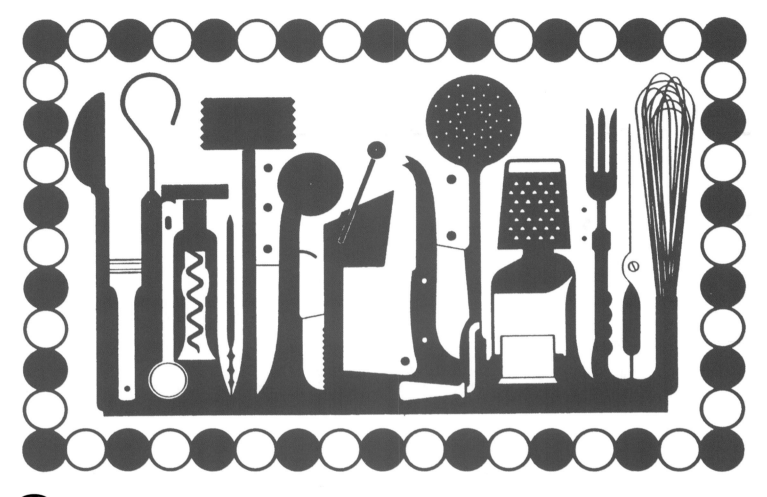

69 **Figure/Ground Illusion:** Do you see purple or white kitchen utensils?

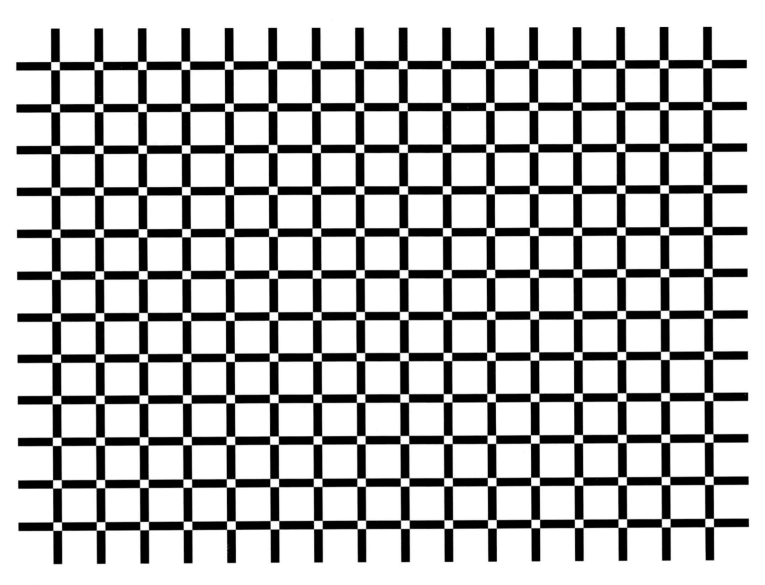

70 **Simultaneous Contrast Illusion:** Do the white dots at the intersections appear slightly whiter and brighter than the white spaces?

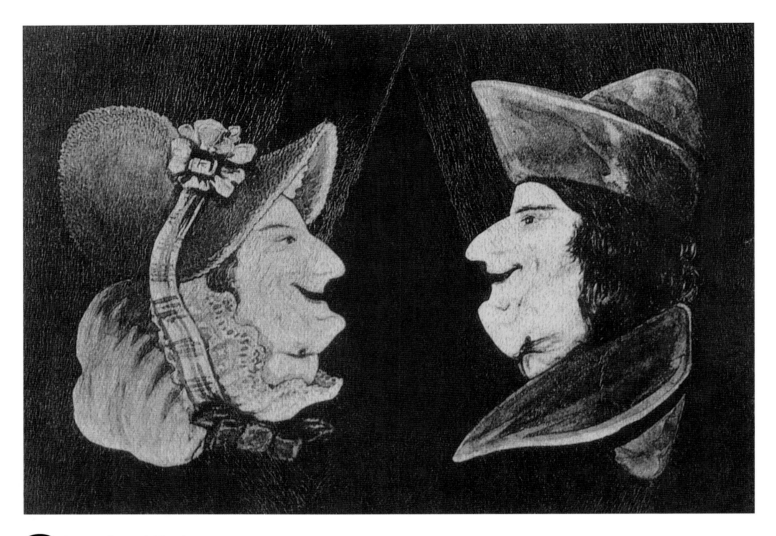

71 **Courtship and Matrimony:**

Is this couple happy or unhappy?

Egyptian-Eyezed Tête-à-tête Do you see one face or two?

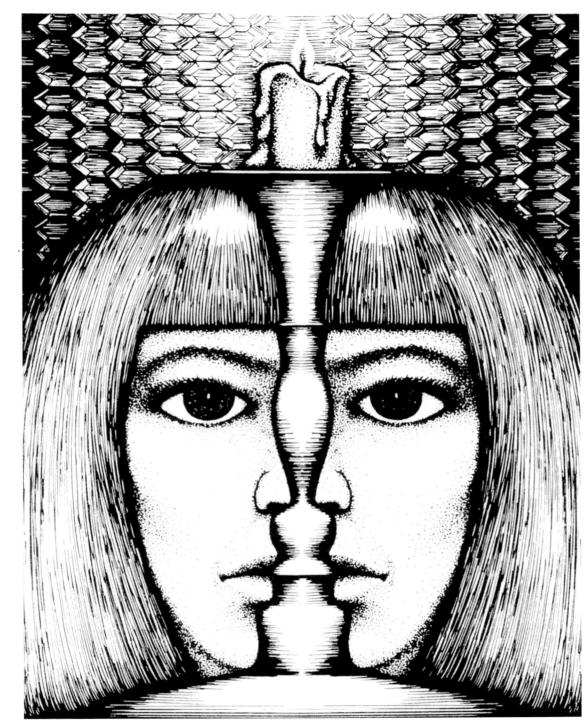

Notes on Gallery II

37. Kitaoka's Waves
Once again your eye and brain are tricking you. The lines are all perfectly straight and parallel in this new variation of the twisted cord illusion by Japanese artist and visual scientist Akiyoshi Kitaoka.

38. Circular Poggendorf Illusion
This is a perfect circle, although the ends do not appear to join together. The left curved section also appears to be slightly smaller than the right.

39. Impossible Chess Set
The chess set is entirely flat. It was created by Bruno Ernst and is based upon a design by Swedish artist Oscar Reutersvärd.

40. Einstein and the Sea
Artist Ken Knowlton creates portraits out of unusual objects. Here, Einstein is created using only seashells. Over the years a number of artists have created such portraits. The Mona Lisa is perhaps the most popular portrait recreated out of strange objects, which have included currency, stamps, little Mona Lisas, and even burnt pieces of toast.

41. Twisted Cord with Squares
The squares appear distorted, but they are all straight and parallel with each other. Bill Chessell created this op art version of the twisted cord illusion.

42. The Müller-Lyer Illusion in Perspective
Believe it or not, both red lines are exactly the same length. Perspective cues greatly enhance this version of the classic Müller-Lyer illusion. The classic version of the Müller-Lyer illusion is much weaker.

45. Boynton Illusion
Most people see the shape of the right yellow figure as defined by the squiggly line. This is known as the Boynton illusion. The edge of the squiggly figure is much stronger than the edge of the yellow figure, and at a distance the stronger edge dominates.

46. Kaniza Triangle
This effect is known as a illusory or subjective contour. The end points of the arc are interpreted as though they are disappearing under a figure, but this interpretation depends critically upon the alignment of their adjacent endpoints.

47. Tolansky's Curvature Illusion
The three arc segments appear to have widely differing curvatures, but they are all identical! The bottom two segments are just shorter arc segments of the top segment. The earliest visual receptors only interpret the world in terms of short line segments. Curvature is perceived when the relative positions of these line segments are summed across a larger area of space. So, when given a small segment of a curve, your visual system cannot detect its curvature.

48. Jittering Square Illusion
This is an example of an orientation contrast illusion. The orientation differences between two nearby edges are exaggerated, most likely by neural connections early on in the visual system. These connections sometimes enhance perceived differences to help our detection of otherwise faint objects. Psychologists Paul Snowden and Simon Watt discovered the Jittered Squares Illusion in 1998.

49. Where's the Pie?
The three-dimensional structure of the pie is ambiguous, and the 'filling' can be interpreted as belonging to either a pie or a pie slice.

50. Where's the midpoint?
Green.

51. Rising Line Illusion
In the absence of stereo information, perceived depth and three-dimensional layout is determined by pictorial cues. In this case, the pictorial depth cues are ambiguous and the lines can be interpreted as both lying flat and rising. The famous psychologist William James discovered this illusion in 1908.

52. Fruit or Portrait
Apparently the Emperor loved this portrait done c. 1590 by Italian artist Giuseppe Arcimboldo.

53. Make the Lightbulb Glow
This is called a negative aftereffect. When you look at a far wall the image should get bigger. Also, try tilting your head - the aftereffect tilts, but the room does not. This demonstrates that this effect is retinal in origin.

54. Ames Room Illusion
In fact, there are two illusions associated with an Ames Room. The first is that the room looks cubic from one special viewing point – the room really has the shape of a trapezoid, i.e., the left corner is twice as far away as the right corner and at a lower elevation. Secondly, the person appears to undergo a size change when moving from one corner to the other. This illusion was originally thought up by the 19th century German physicist Hermann von Helmholtz, but it was Adelbert Ames, Jr., who built and publicized the first physical example in 1941 and hence the illusion was named after him.

55. Camouflage
Symmetry can be a powerful and simple device to produce camouflage. Cover the left half of every symbol to reveal the answer.

57. Illusory Sphere
The bottom edges of the cones help suggest the three-dimensional surface of the illusory sphere. Peter Tse designed this illusory three-dimensional figure.

58. The Woman with Closed Eyes
This illusion is related to the Mach band illusion, where a dark area shading into a light area appears to have greater lightness differences than actually exist: dark areas look darker, and light areas look lighter. When you stare at the woman's eyes, the differences between the dark and light areas become exaggerated, and the dark areas begins to resemble pupils.

59. Folded Chess Set
Both interpretations are possible in this drawing by Swiss artist Sandro Del Prete.

60. Ponzo Illusion
All five balls look like they are misaligned but they are all perfectly aligned. This is a variation of the Ponzo illusion.

61. Height/Breadth Illusion
In fact, the stack on the right is equally wide and high, but the horizontal stripes fool your brain. This illusion is well-known to fashion conscious people – vertically striped clothes tend to make the person wearing the clothes appear taller and thinner, while broad, horizontal stripes will emphasize breadth.

62. Homage to Leonardo Da Vinci
Look closely at Da Vinci's face and then closely at the mule and rider! Swiss artist Sandro Del Prete created this ambiguous drawing.

63. Simultaneous Orientation Contrast
They are both vertical and parallel. It is not clear what causes this illusion, but one theory is is based on the hypothesis that there are inhibitory interactions among orientation selective neurons. In other words, the neural connections in your visual system are wired to respond more strongly to differences than to similarities in a visual scene. This can exaggerate the lines' orientations.

64. Bezold illusion
Context can influence your perception of color. All the reds are exactly the same! This is known as the Bezold color illusion.

66. Sara Nader
Stanford psychologist Roger Shepard aptly titled this ambiguous figure/ground illusion, "Sara Nader.".

68. Hidden Figure
It is the head of a cow.

69. Figure/Ground Illusion
You can see purple or white utensils by reversing what constitutes the figure and ground.

70. Simultaneous Contrast Illusion
The white squares appear slightly whiter even though there is no difference. The small white squares appear as if they lie on a black background, enhancing the lightness contrast between each small square and its background.

71. Courtship or Matrimony
This German 19th century topsy-turvy illustration was created by a disgruntled ex-husband or wife. The couple is perceived as being happy in "courtship," but if you turn the image upside down, you will see that the couple is unhappy in "marriage."

72. Egyptian Eyezed Tete-a-tete
If you see one face, you get a perception of depth, because the face would be behind the candlestick. Stanford psychologist Roger Shepard created this charming variation on the face/vase illusion.

73. The Margaret Thatcher Illusion
This is a facial illusion and it indicates that there is a special area of the processing of facial expressions that only works with upright faces. Because the face is upside down, this facial area is inactive. English vision scientist Peter Thompson discovered the Margaret Thatcher illusion. Only the eyes and the mouth are inverted.

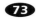 **The Margaret Thatcher Illusion:**
What is wrong with this portrait of the former British Prime minister Margaret Thatcher? Turn the photo upside down for a clue.

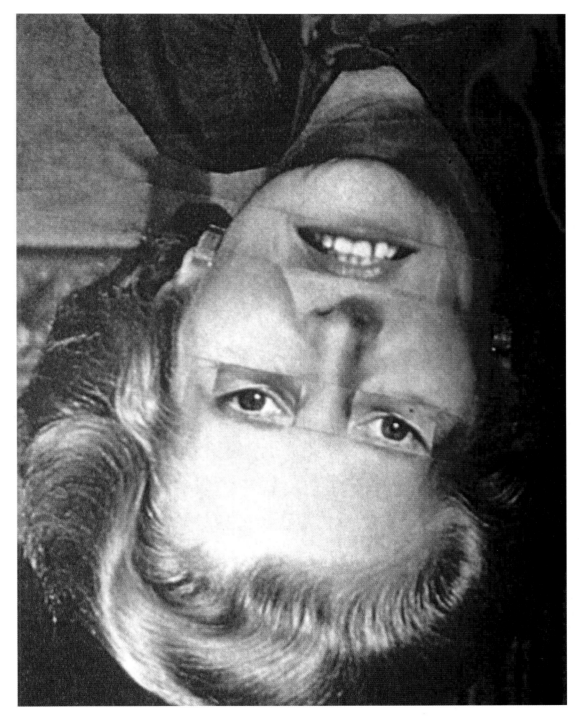

GALLERY

III

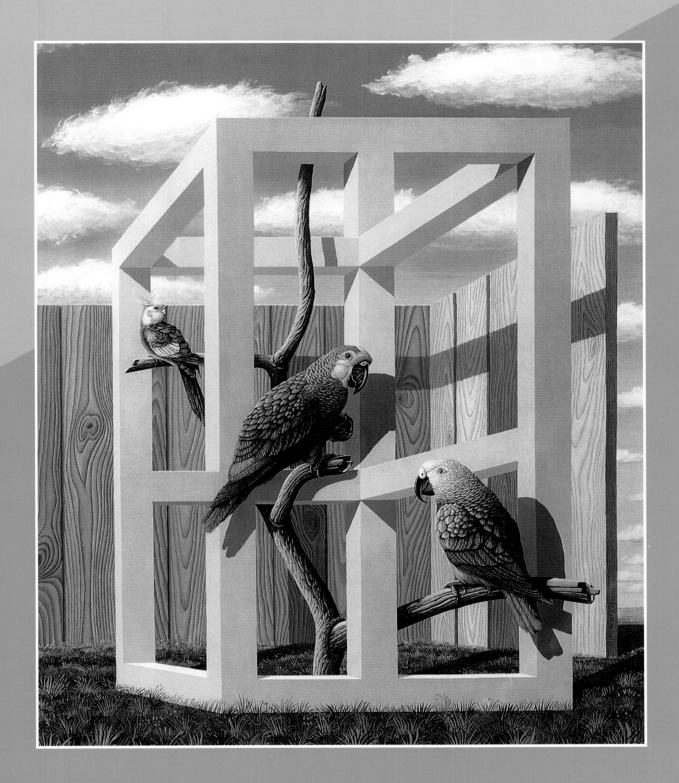

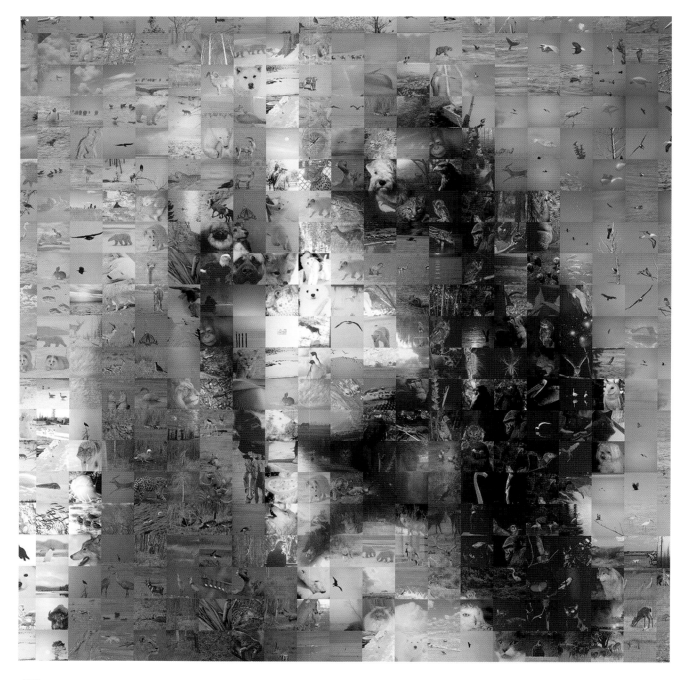

74 **Illusion Collage:** This image of basset hound was made out of a collage of animal images.

Previous page **Impossible Bird Cage:** Flemish artist Jos De Mey has created an impossible bird cage for these parrots.

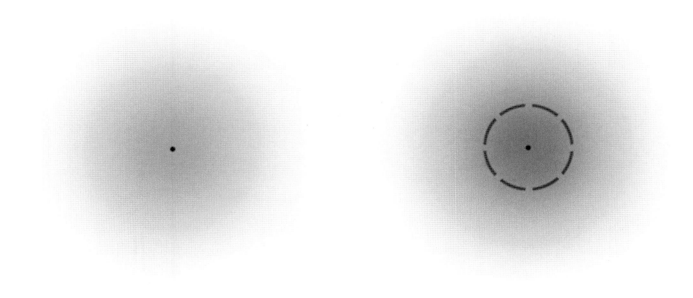

75 **Filling-in Illusion:** With one eye, stare at the center of the dot in the middle of the left smudge without moving your eye. After a few seconds the left smudge will disappear. Try this again with the center dot in the middle of the smudge on the right. This time the smudge will not disappear.

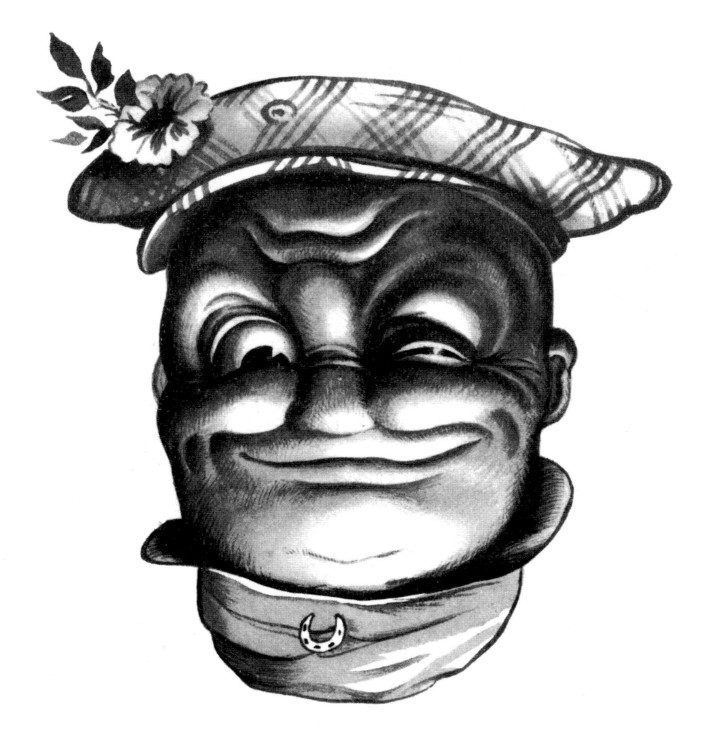

76 **Aging Illusion:** *What will this young man look like when he gets older?*
Turn the image upside down to find out.

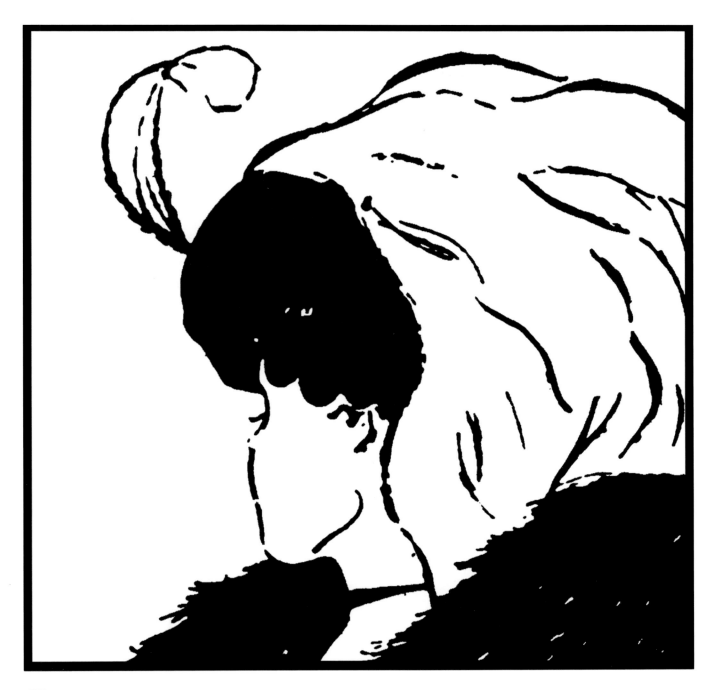

77 **My Wife and Mother-in-Law:** Do you see the profile of a young or old woman?

 Shade of Napoleon:
Can you find the standing
figure of Napoleon? This
figure/ground illusion
appeared shortly after
Napoleon's death.

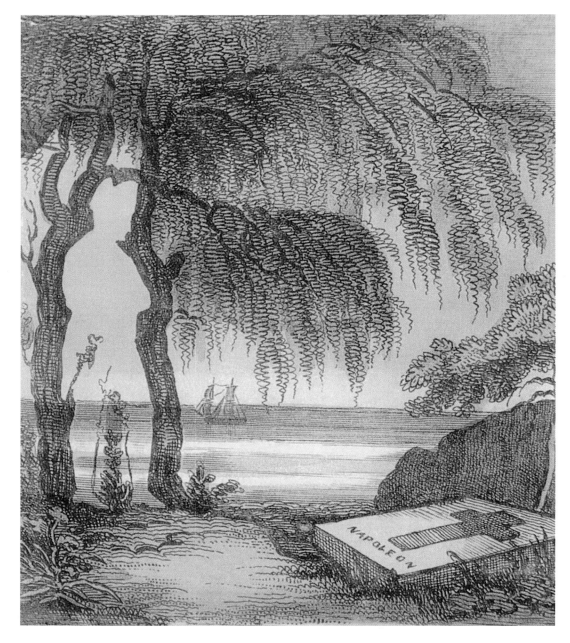

79 Illusion Causing Another Illusion: This is a wonderful example of an illusion causing another illusion! At the intersection you will see faint, ghostly dots (Hermann Grid Illusion). These dots give rise to an impression of a series of concentric circles.

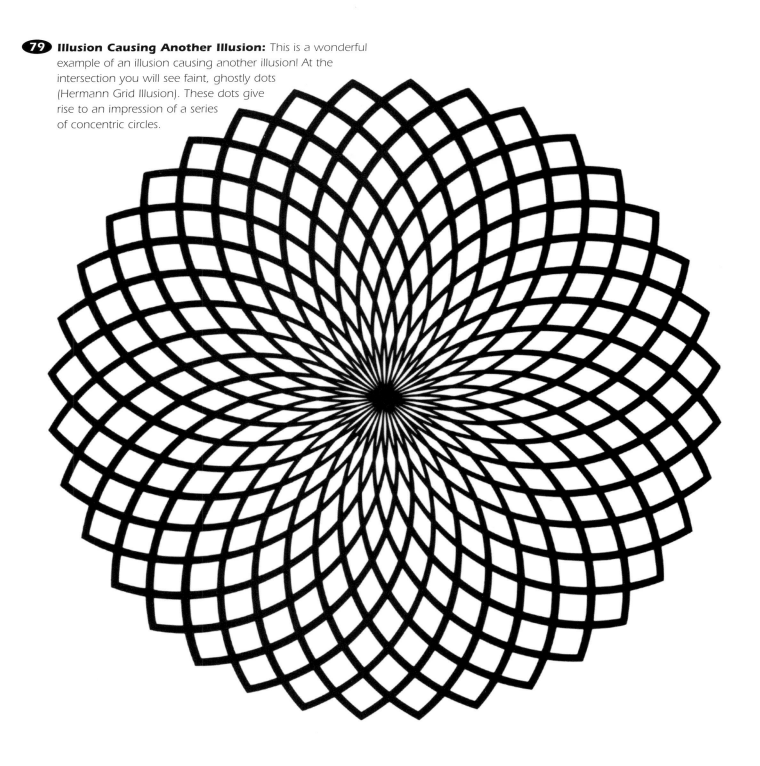

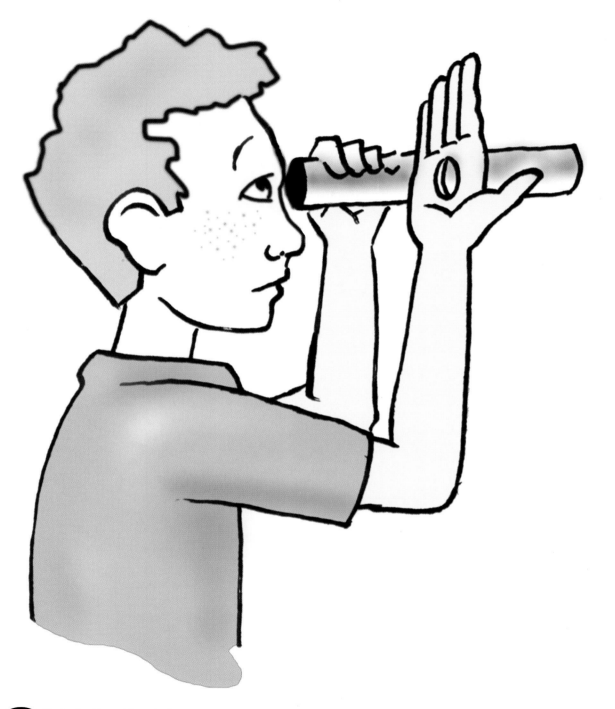

80 **Hole in Your Hand:** Create a hole in your hand! Hold a tube up to your eye. Look at something 15 feet away with both eyes (one looking through the tube). Then bring your free hand up in front of the eye that is not looking through the tube. You will see the object through a round hole in the palm of your hand! For an interesting variation, place a coin in the center of you palm and it will appear to float!

81 Box Illusion: Look at the figure on the outside of the cube. Which line is perpendicular to the vertical line and which line is at a slant? Cover just the outline of the cube and you will see your perception change.

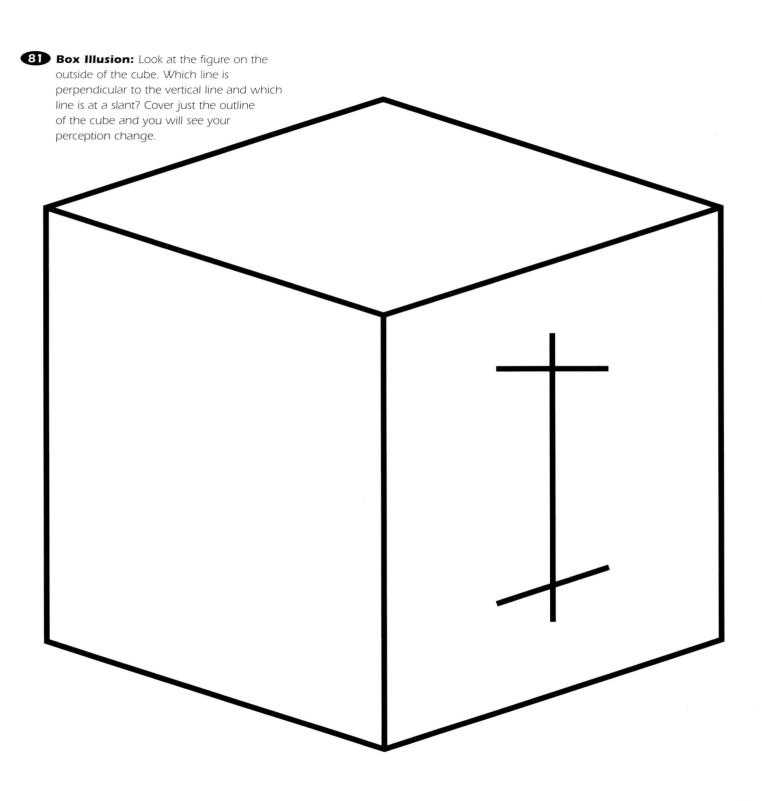

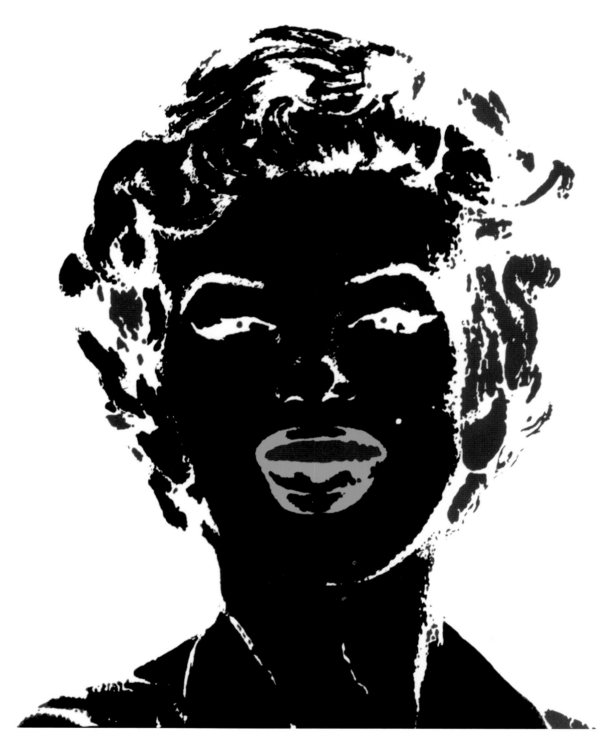

82 **Marilyn Monroe Afterimage:** *Stare at the image of Marilyn Monroe for thirty seconds or more without shifting your gaze. Then quickly look at a solid white or gray background. You will see her lips in red!*

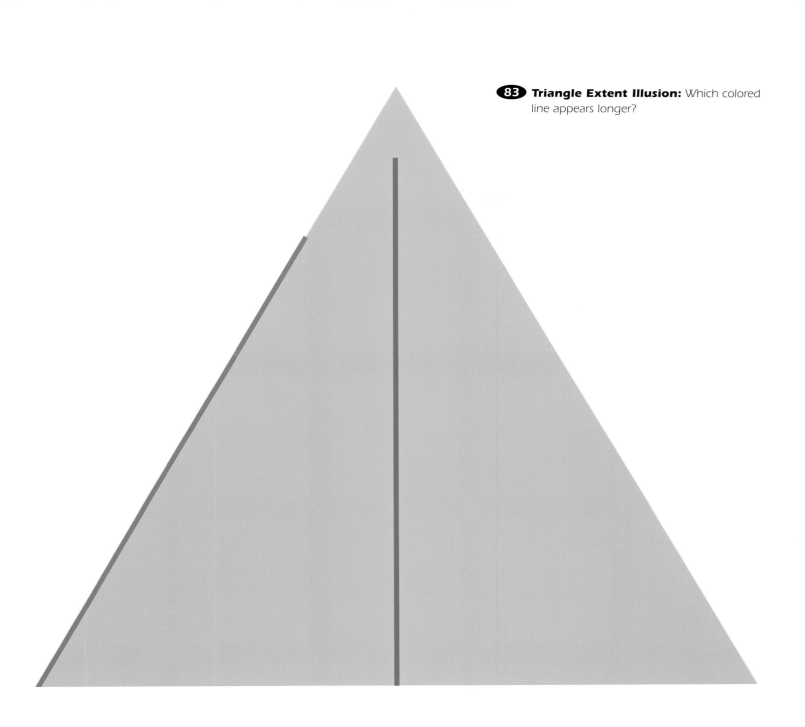

83 Triangle Extent Illusion: Which colored line appears longer?

84 **Hermann Grid Illusion:** You will see ghostly blue dots at the intersections. If you look directly at any dot it will disappear.

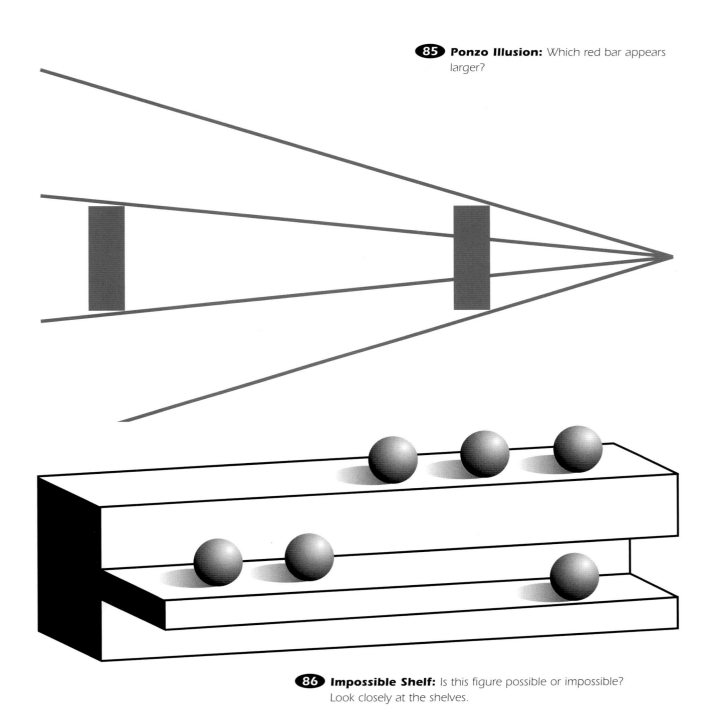

85 Ponzo Illusion: Which red bar appears larger?

86 Impossible Shelf: Is this figure possible or impossible? Look closely at the shelves.

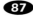 **Terra Subterranea**

*Which figure appears
larger?*

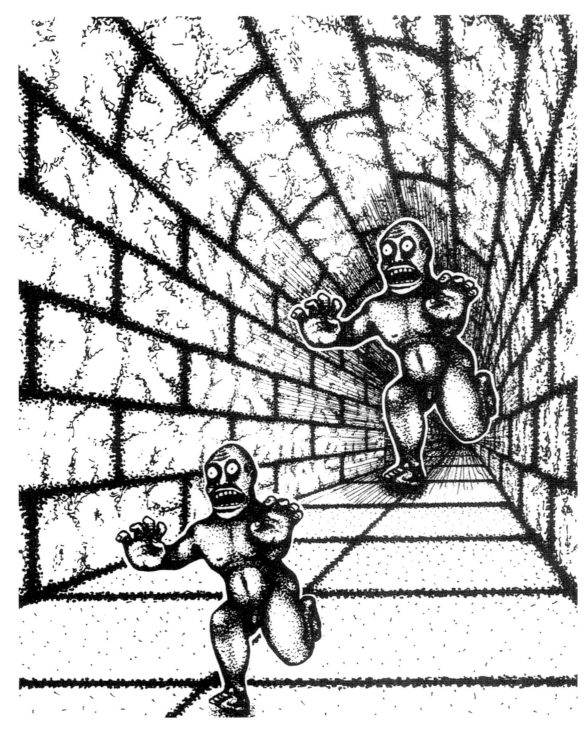

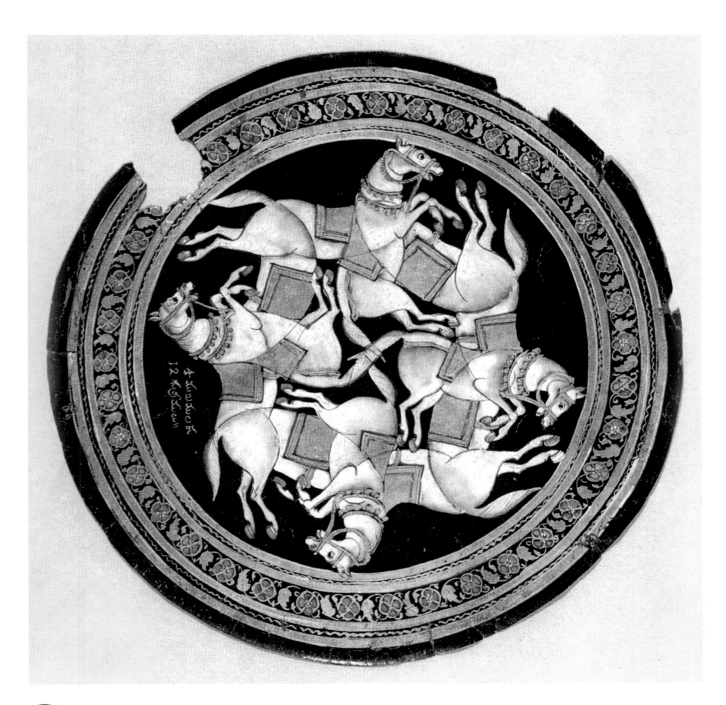

88 **Persian Horses with too Many Bodies:** How many horses are here?

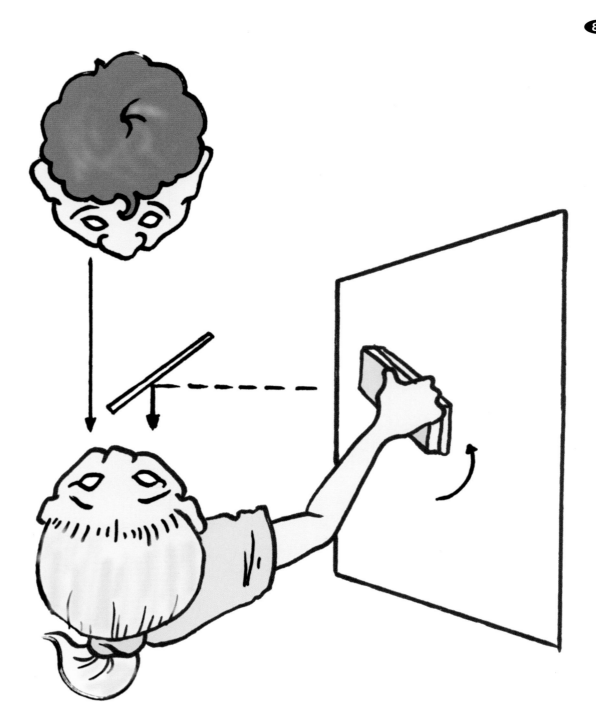

89 **Cheshire Cat Illusion:**
This is a truly amazing illusion that requires a little bit of a set-up, but it is worth it. Sit so that a white surface is on your right. Hold the bottom of a mirror with your left hand so that the mirror faces right Put the mirror edge against your nose so that the reflecting surface faces the wall. Rotate the mirror so that your right eye sees just the reflection of the wall, while your left eye looks forward at the face of a friend sitting about two feet away. Move your hand in a circular motion in front of the white surface with a blackboard eraser. Watch, as parts of your friend's face will disappear!

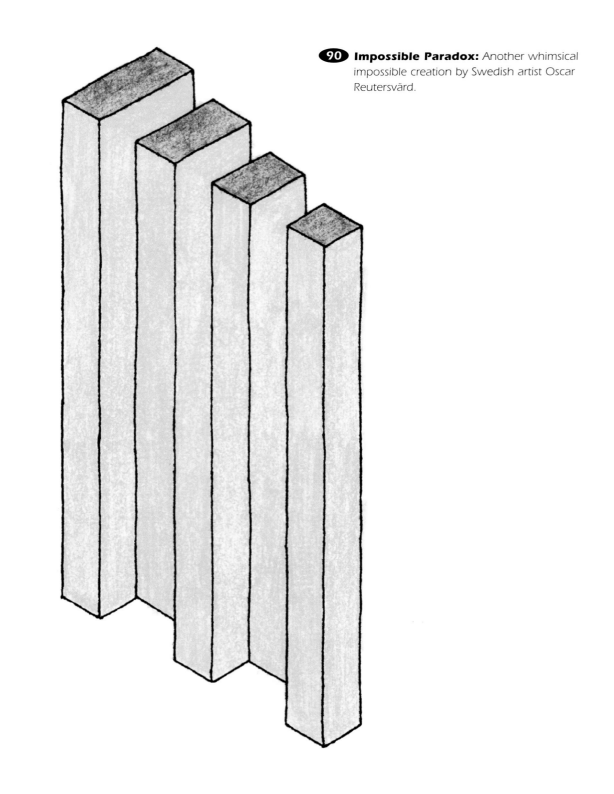

90 Impossible Paradox: Another whimsical impossible creation by Swedish artist Oscar Reutersvärd.

91 **Human Condition I:**
Is the tree outside or
inside the room?

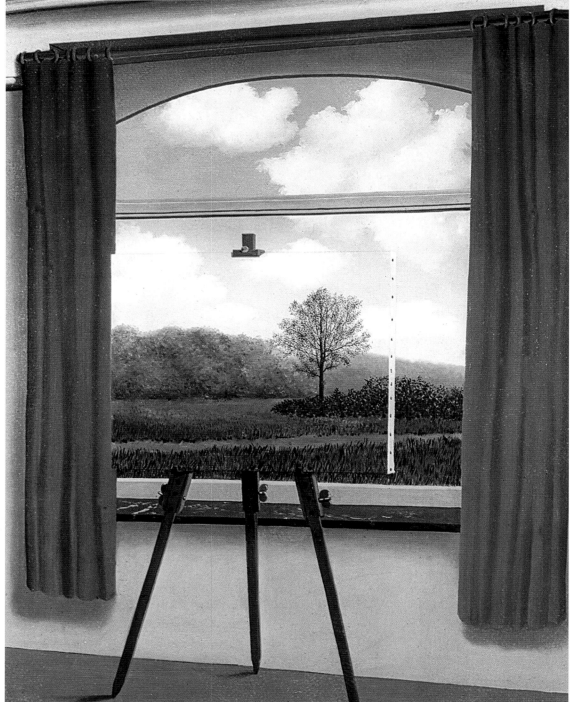

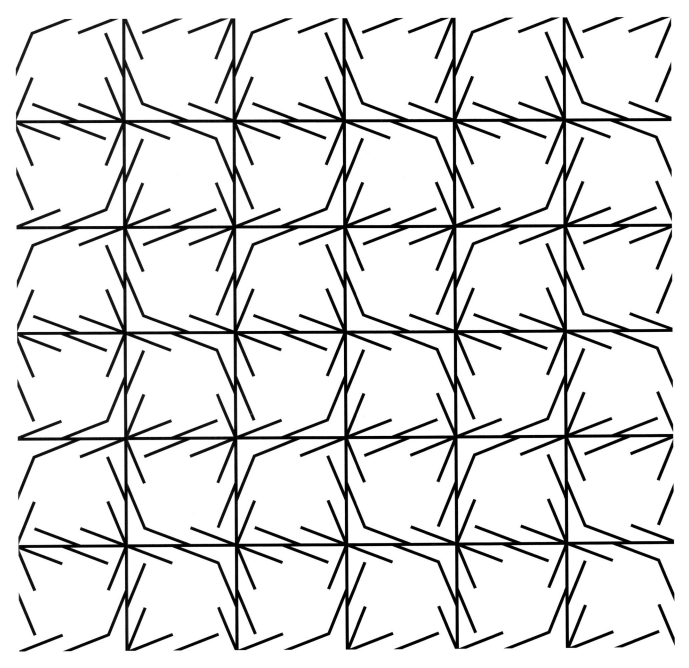

92 **Zöllner Illusion:** Do the horizontal lines appear straight and parallel? Or do they appear at angle with respect to each other?

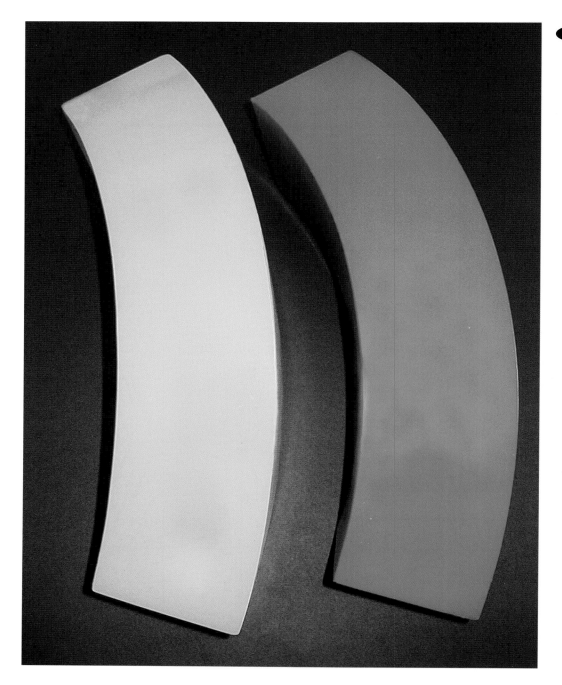

93 Wundt Block Illusion:
Which colored block appears larger?

94 **Clown or Circus?** Here you see an illustration of a clown's face, but can you also find the circus?

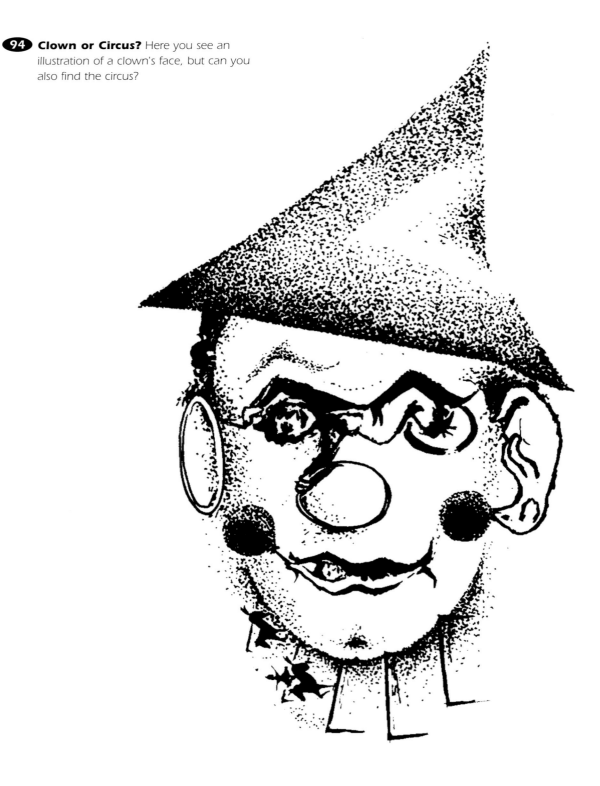

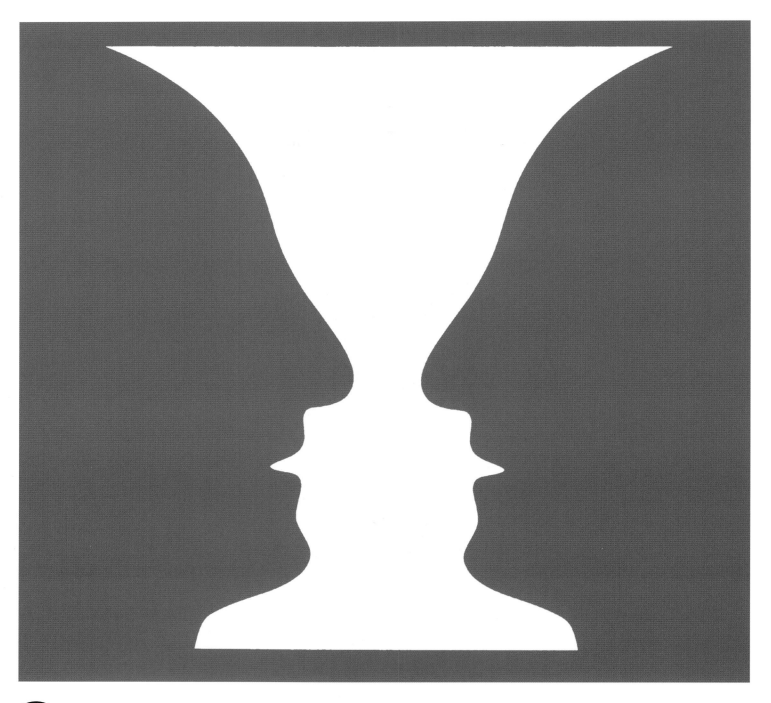

95 **Rubin's Face/Vase Illusion:** Do you see a vase or two heads in profile?

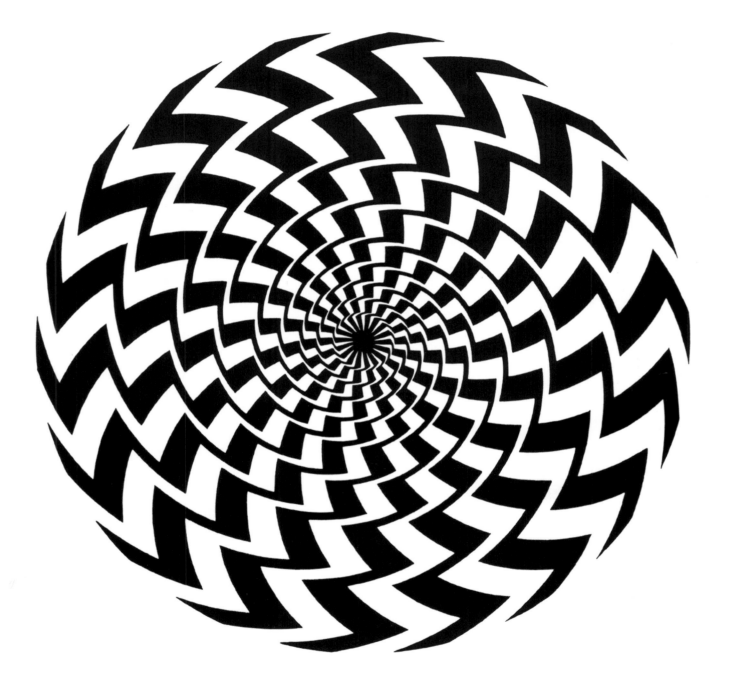

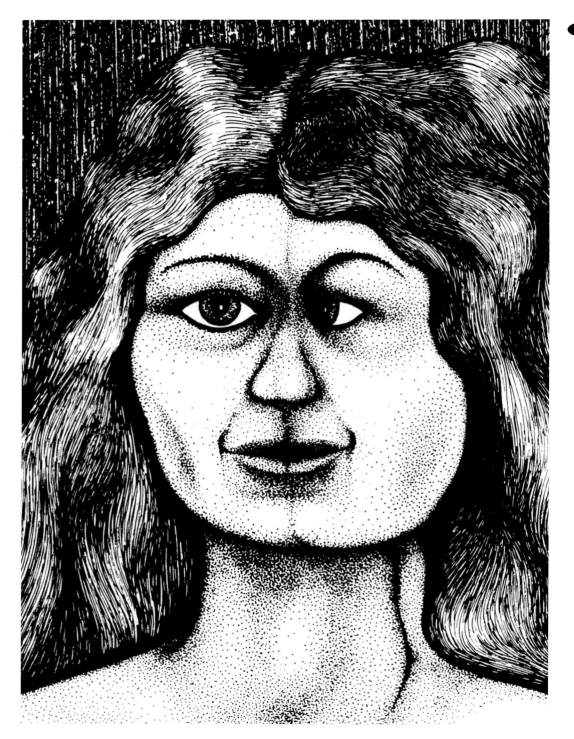

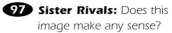

98 L'Egs-istenial
Quandary: This elephant
will have trouble walking!

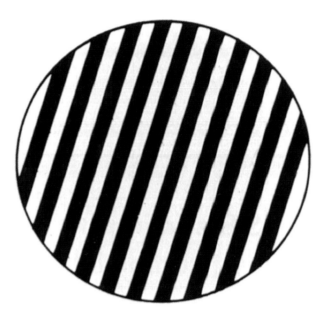

99 **Orientation Aftereffect:** *Stare at the left-hand grating for thirty seconds or more without moving your gaze. Quickly stare at the right-hand grating. You should see the right-hand grating appear to bend.*

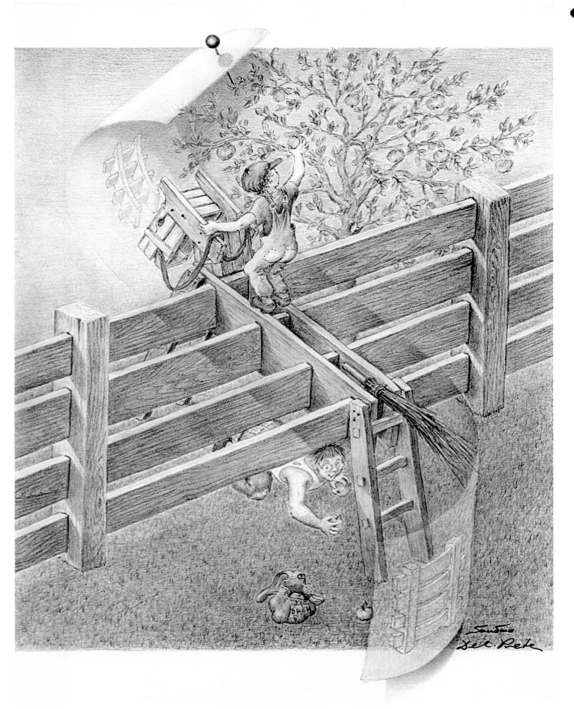

101 **Kitaoka's Distorted Square Illusion:** Do the squares appear slightly distorted?

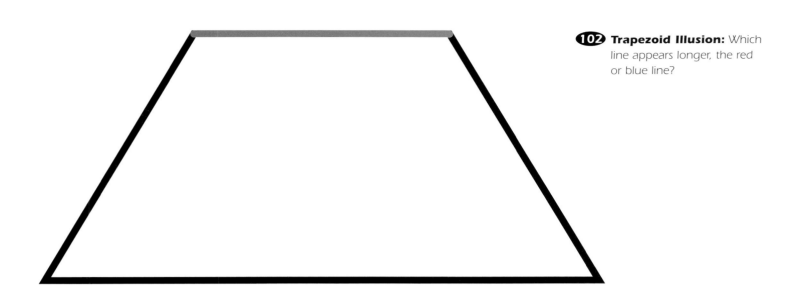

102 **Trapezoid Illusion:** Which line appears longer, the red or blue line?

 Illusory Torus: Do you see a white doughnut even though there are no edges, shadows, or contours to define it?

104 Hidden Figure: What do you see here?

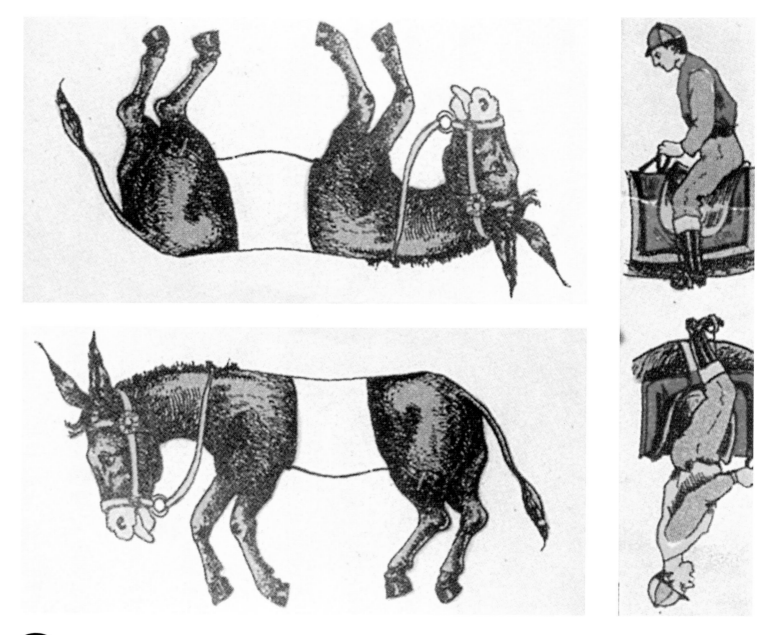

105 **Mule and Jockey Puzzle:** This is one of the best puzzles of all time. Cut out the three pieces. The trick is to get the rider to mount both animals at the same time without overlapping the two larger pieces. The horses should break into a gallop when it is correctly assembled.

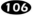 **Corporal Violet:** Can you find the three profiles hidden between the leaves?

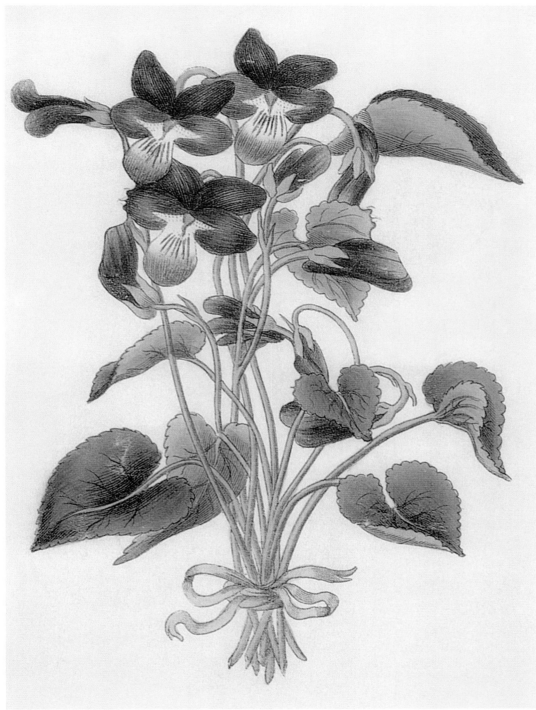

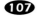 **Gesture of a Dancer.**
Both the hand and the
dancer show grace of
movement in this
ambiguous drawing
by Swiss artist
Sandro Del Prete.

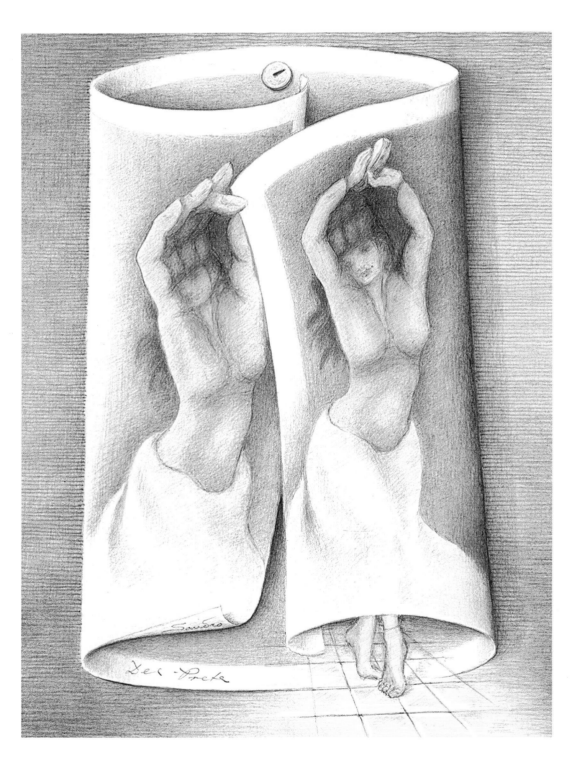

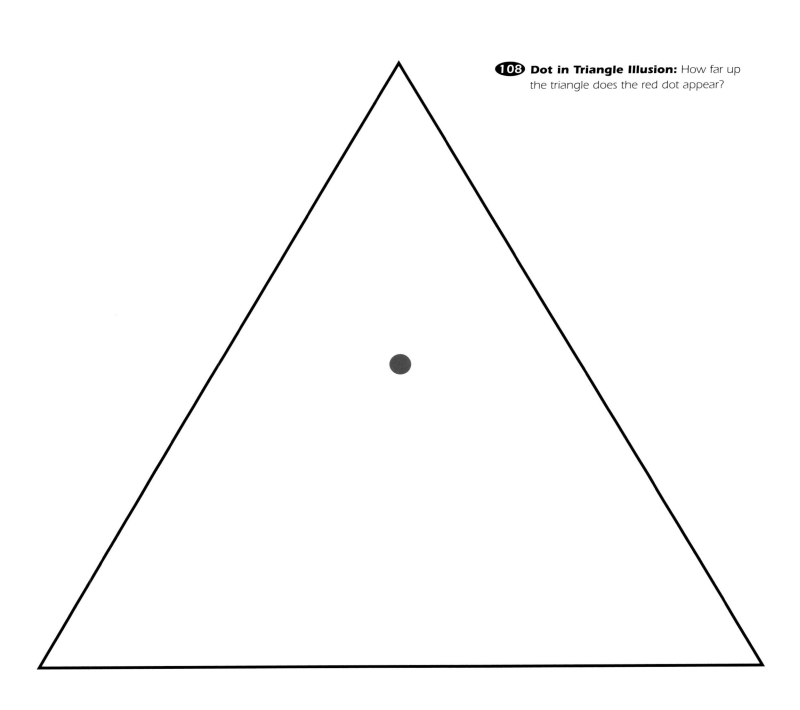

108 **Dot in Triangle Illusion:** How far up the triangle does the red dot appear?

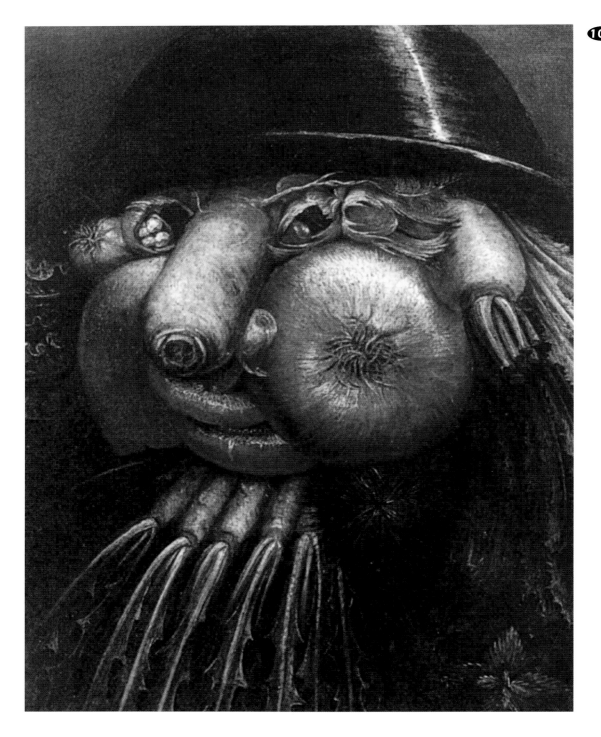

120

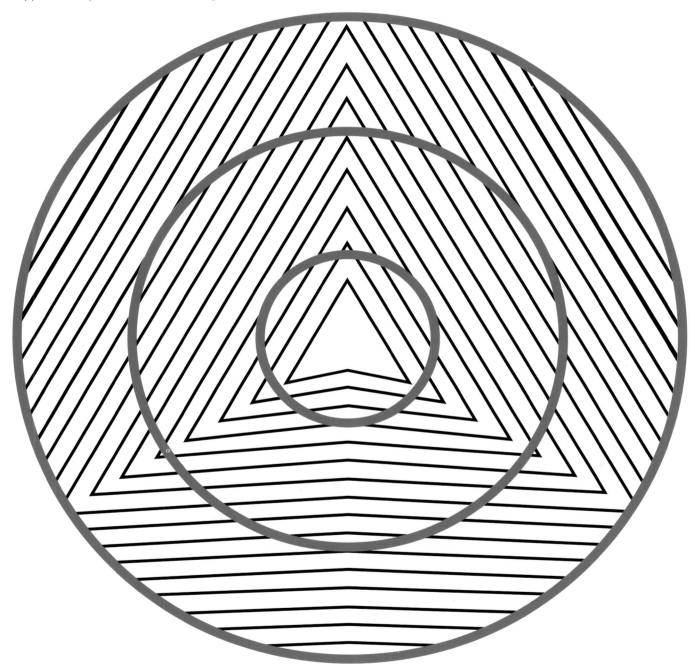

Notes on Gallery III

75. Filling-in Illusion
Your visual system only responds to the presence of change in a visual scene. Your eyes are constantly making tiny eye movements, which help to keep the visual scene changing and thus visible. In the left figure, your eye movements change the position of the center dot, but that dot by itself is too small to affect most of the smudge. In the right figure, your eye movements cause the entire dotted circle to move and its size allows most of the smudge to be refreshed.

76. Aging Illusion
Rex Whistler created this topsy-turvy portrait.

77. My Wife and Mother-in-Law
Both interpretations are possible. This classic illusion demonstrates how your visual system tends to group features based upon what you expect to see. The American psychologist Edwin Boring made this classic illusion of perceptual ambiguity popular. Boring adapted the figure from a popular 19th century puzzle trading card.

78. Shade of Napoleon
He is hiding in between the trees. The outlines of the inner trunks of the trees form the standing figure of Napoleon.

79. Illusion Causing Another Illusion
Vision scientist and op artist Nicholas Wade created this wonderful illusion causing an illusion.

80. Hole in Your Hand
Your visual system fuses the images from both eyes, resulting in the hole in the hand.

81. Box Illusion
The perspective cues of the box provide a context for the orientation of the line segments of the central figure. Remove the box and your visual system must use another context. This is known as the box illusion.

82. Marilyn Monroe Afterimage
This effect is known as a colored afterimage. When you stare at any color, you will briefly get its complimentary color in an afterimage.

83. Triangle Extent Illusion
The green line appears to be longer than the red line, although they are both identical in length.

84. Hermann Grid Illusion
This is a coloured variation of the Hermann Grid Illusion. If you make the squares black then you will see ghostly gray dots at the intersections. These ghostly dots arise as a side-effect of how the neural circuitry in the retina operates.

85. Ponzo Illusion
Both bars are identical in size, although the inner bar appears to be larger. This is known as the Ponzo illusion. This perspective illusion is greatly enhanced by the two center radiating lines.

86. Impossible shelf
It's impossible.

87. Terra Subterranea
The background figure appears to be larger than the foreground figure even though they are both identical in size. If you could somehow move the background figure to the same level as the foreground figure the illusion would no longer work. Stanford psychologist Roger Shepard created this perspective illusion.

88. Persian Horses with too Many Bodies
Count the heads and then count the bodies. This ambiguous illusion was created in Persia sometime during the 17th century.

89. Cheshire Cat Illusion
The image you see is actually the combination of two different images; you notice your friend's face because it is more interesting than the white wall. When you move your hand, your visual system replaces portions of your friend's face with white because the motion of your hand suddenly draws more attention to the white wall. Sally Duensing of the Exploratorium, an excellent hands-on science museum in San Francisco, discovered the Cheshire Cat illusion.

91. Human Condition I
In 'Human Condition I', Flemish artist René Magritte was determined to depict the ambiguity that exists between a real object, one's mental image of it, and its painted representation.

92. Zöllner Illusion
The lines are straight and parallel even though they appear to be bent. This is another variant of the classic Zöllner illusion.

93. Wundt Block Illusion
They are identical. This illusion still works when you hold them in your hands.

94. Clown or Circus?
Turn the illustration on its side. Artist Larry Kettlekamp created this charming topsy-turvy illusion.

95. Rubin's Face/Vase Illusion
One can see both interpretations. At any time, however, you can only see either the faces or the vase. If you continue looking, the figure may reverse itself several times so that you alternate between seeing the faces and the vase. The Gestalt psychologist Edgar Rubin made this classic figure/ground illusion famous. Rubin had drawn his inspiration for this illusion from a 19th century puzzle card.

96. Wade's Spiral
English vision scientist and op artist Nicholas Wade gives us his version of the Fraser Spiral illusion. Although it looks like a spiral, it is really a series of concentric circles.

97. Sister Rivals
This illusion by Roger Shepard is called 'Sister Rivals'. The only way it really makes sense is if you see two people.

99. Orientation Aftereffect
This illusion is known as a tilt aftereffect. It occurs because the orientation detectors in your retinas become fatigued and its signal becomes much weaker relative to other orientation detectors.

101. Kitaoka's Distorted Square Illusion
The squares are perfect. This is another op art variation on the twisted cord illusion by Japanese artist and vision scientist Akiyoshi Kitaoka.

102. Trapezoid Illusion
The red line appears slightly longer than the blue line, even though they are both identical in length. Angles of less than 90 degrees make the enclosed line appear shorter while angles of more than 90 degrees make it appear longer. This is known as the trapezoid illusion.

103. Illusory Torus
Peter Tse provided the inspiration for this three dimensional illusory contour figure.

104. Hidden Figure
You will see the face of a bearded man.

105. Mule and Jockey Puzzle
The great American master of puzzles Sam Lloyd created this wonderful puzzle. The solution involves an illusion! The bodies of the mules are ambiguous.

108. Dot in Triangle Illusion
The red dot is located exactly halfway up the triangle, although it appears to be much higher. This is a variation of the upside-down T illusion.

109. First Topsy-Turvy
This topsy-turvy illusion by 16th century Italian artist Giuseppe Arcimboldo is the earliest attempt at a topsy-turvy illusion known.

110. Distorted Circle Illusion
The perfect circles appear distorted when placed on top of this background. This is another example of an orientation contrast illusion, where each pair of intersecting lines appear more perpendicular to each other than they physically are.

111. Flowering of Love
Swiss artist Sandro Del Prete created this romantic and ambiguous illusion.

111 Flowering of Love: Can you see the two lovers in the rose petals?

GALLERY
IV

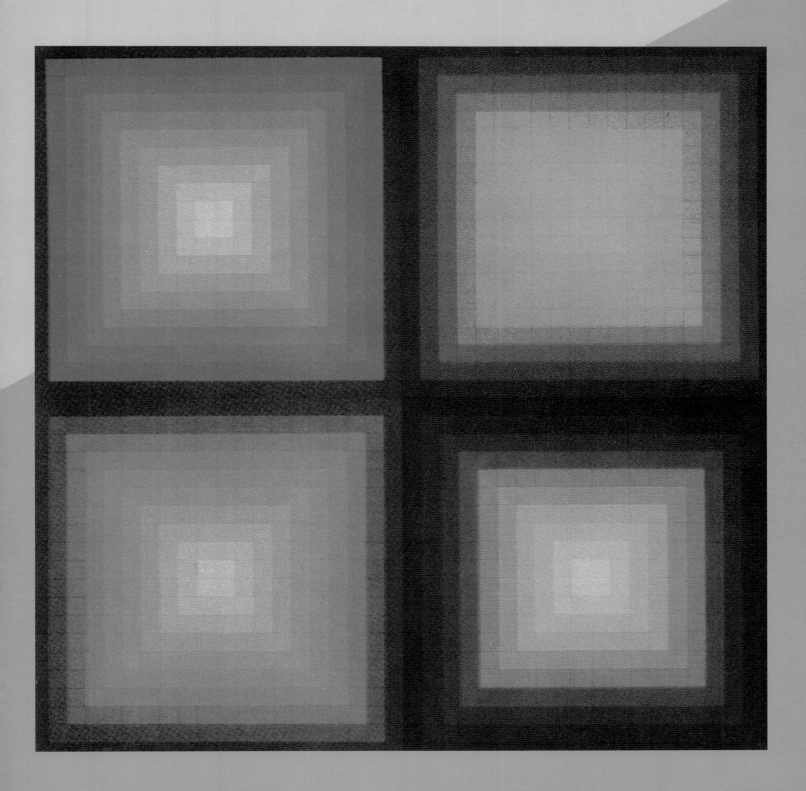

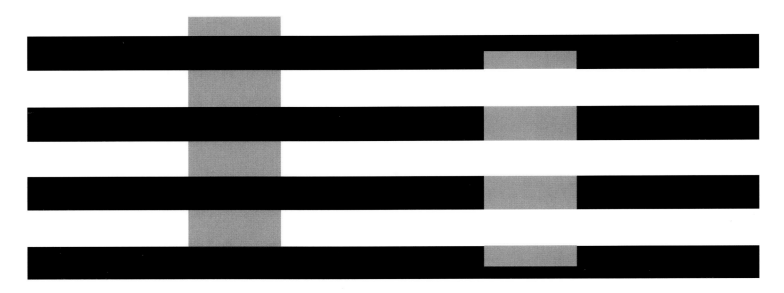

112 **White's Illusion:** Do the gray vertical bars appear identical or different?

Previous page **Arcturus II:** Do you see four Xs in each colored pattern? The Xs are an illusion.

113 **Thiery's Figure:**
Where is the white square located?

 114 Gazing Illusion: The two men appear to be looking in different directions. Cover up everything below their eyes and you will now see them gazing in exactly the same direction.

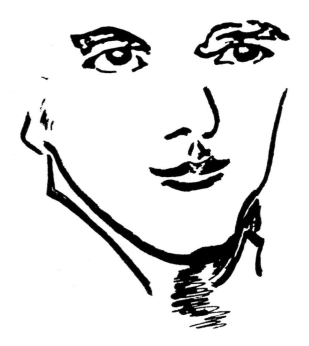

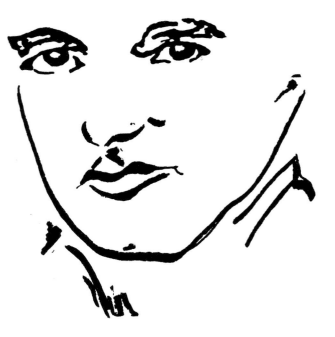

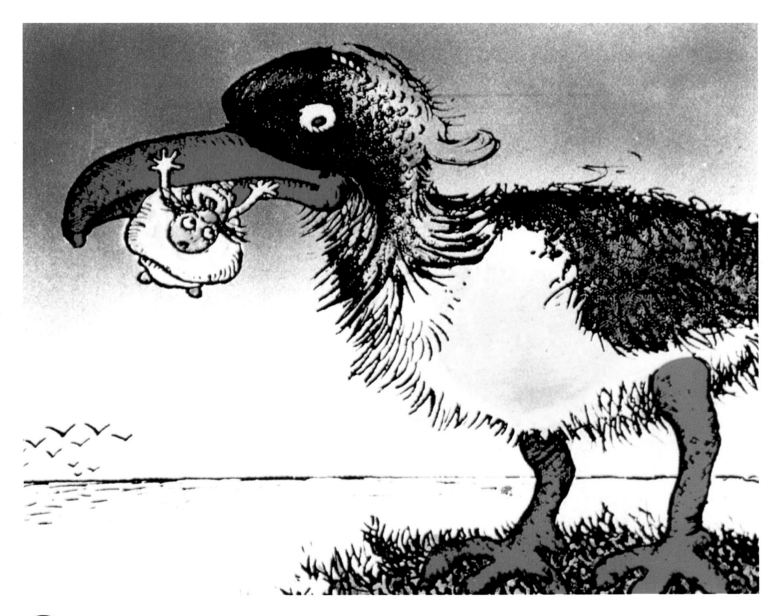

115 **Verbeek's Topsy-Turvy Cartoon:**
Turn this image upside down and you will
see another scene.

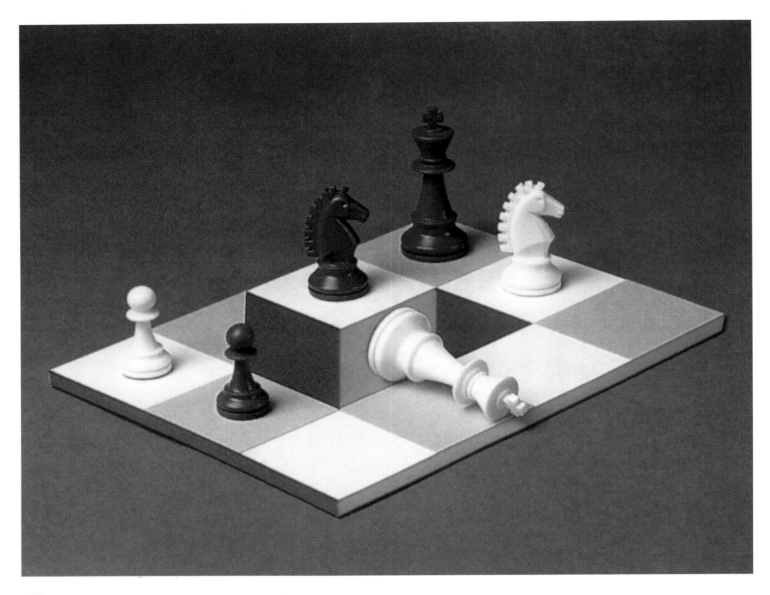

116 Chess set: How is this chess set possible? Can you tell how it was made?

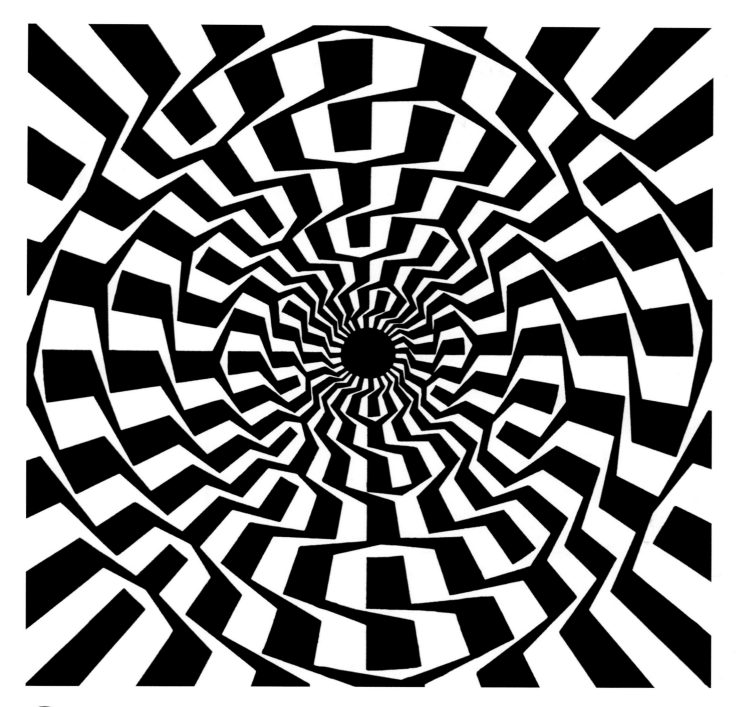

117 **Twisted Circles.** This is a series of perfect concentric circles! This is an example of a twisted cord illusion

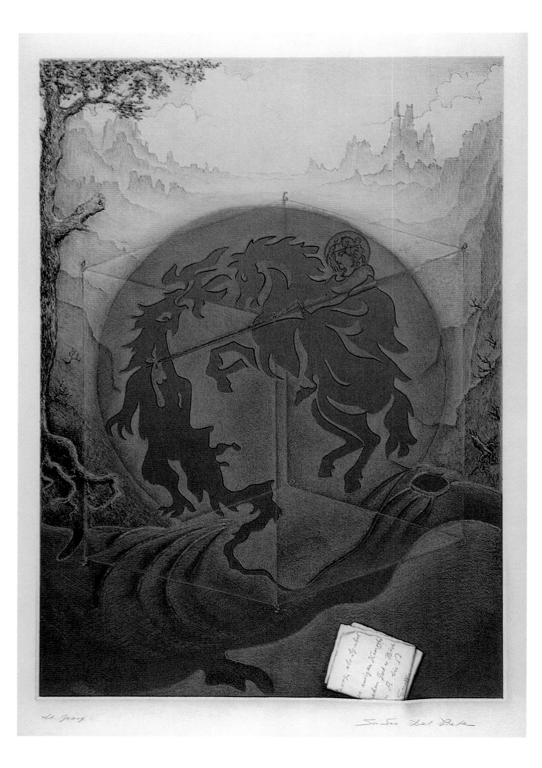

118 **St. George and the Dragon:** Can you find both a portrait of St. George and a depiction of his slaying of the dragon?

119 **E Puzzle:** Cut out the three pieces and arrange them to form the letter E. The solution involves an illusion. The solution just might prove illusory.

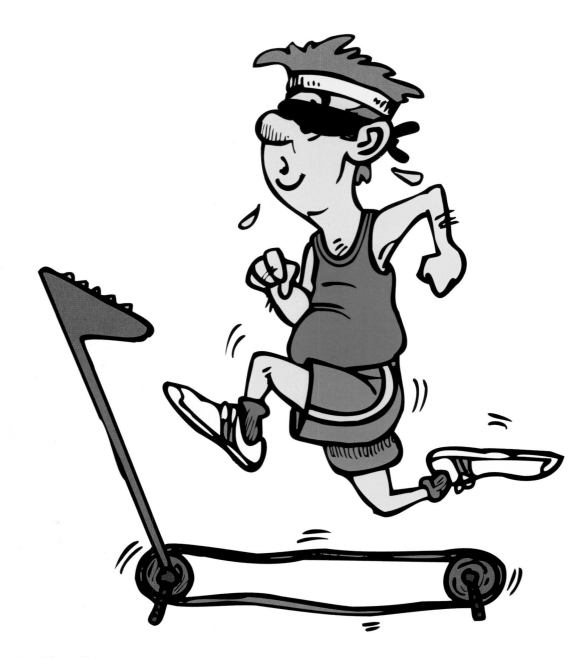

120 **Muscular Aftereffect:** This is a fun jogging illusion that you can do with a friend. Have your friend run on the treadmill for about three minutes while blindfolded. Quickly help them off the treadmill and ask them to run in place, while still blindfolded. They will run forward, even though they think they are running in place.

 Minimum Visible: If you look closely at this image you will see only dots. If you back away and look at it from just the right angle you may see a face.

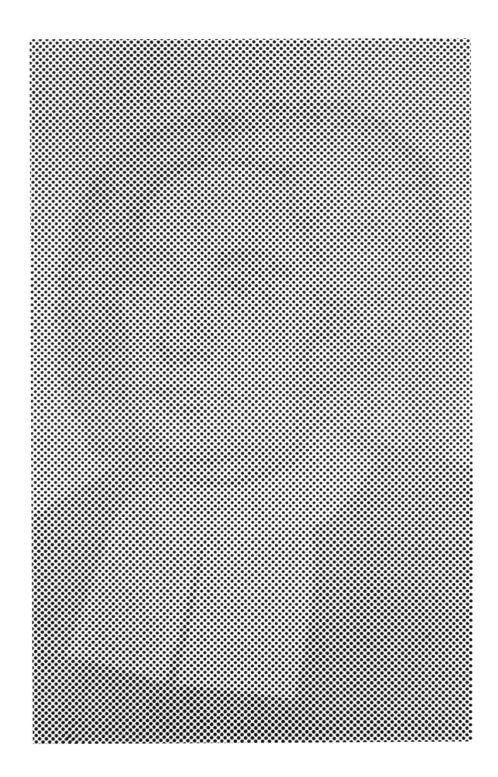

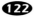 **Hering Figure:** Do the black lines appear to be bowed out?

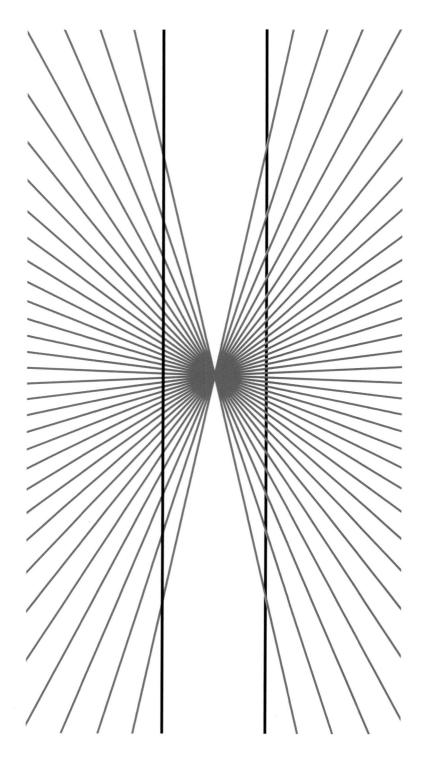

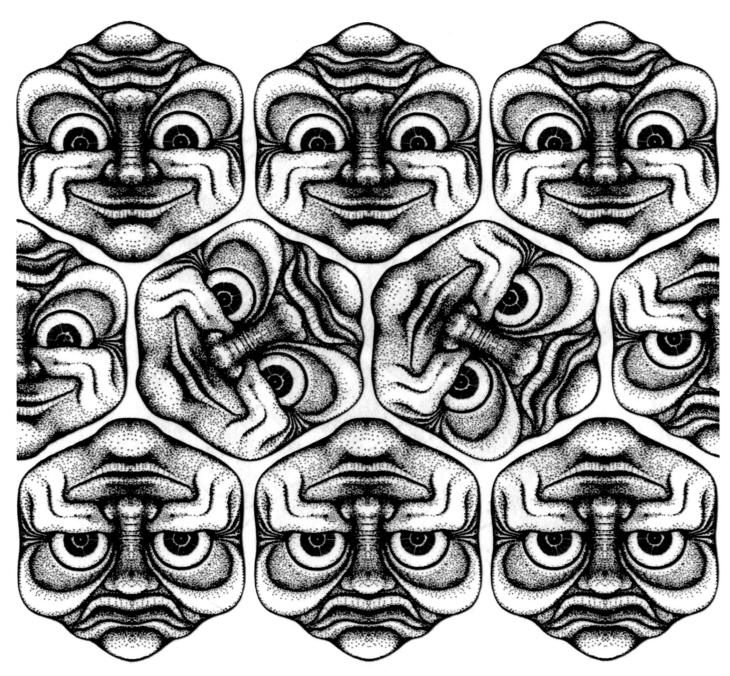

123 **Glee turns Glum:** One moment they are happy and in another moment they are sad. You can switch their moods by inverting the image.

 124 Neptune: Can you find the invisible figure of Neptune guarding the sea?

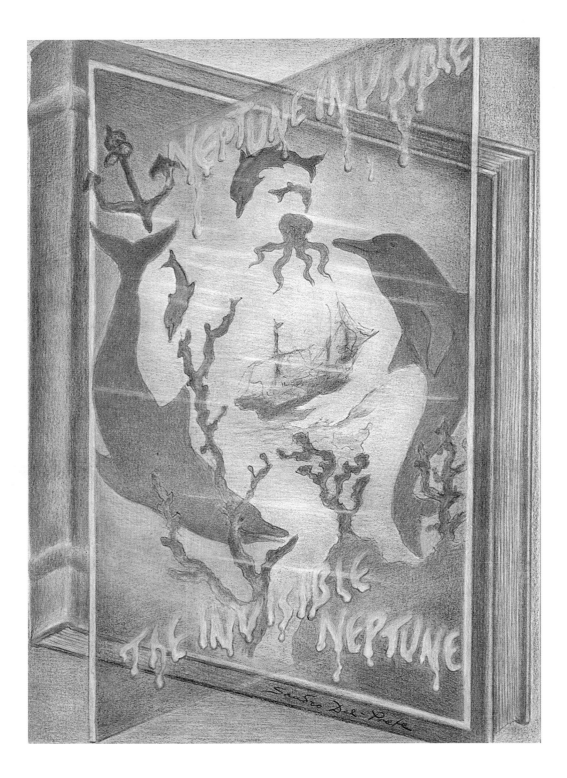

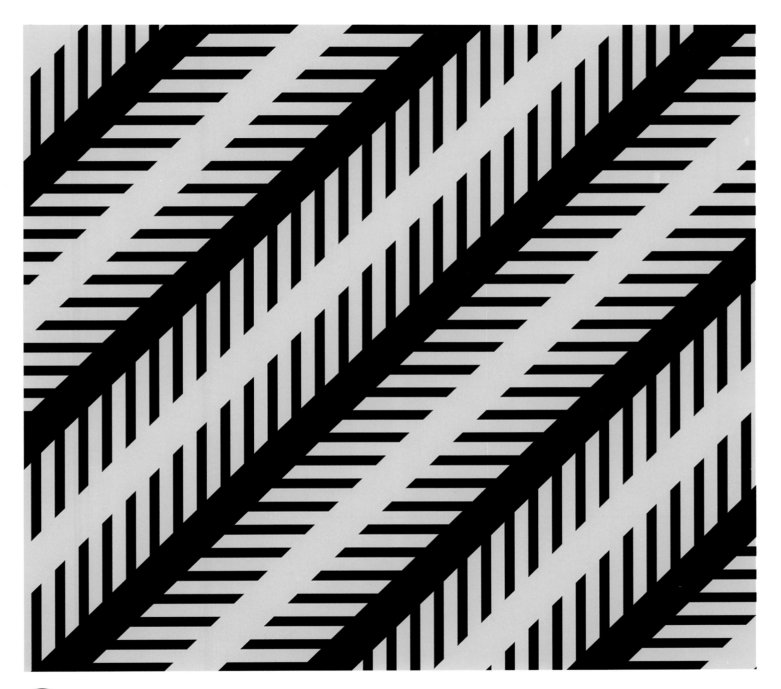

125 Zollner. Are the thick black lines and the open spaces between them exactly parallel to one another? Look again

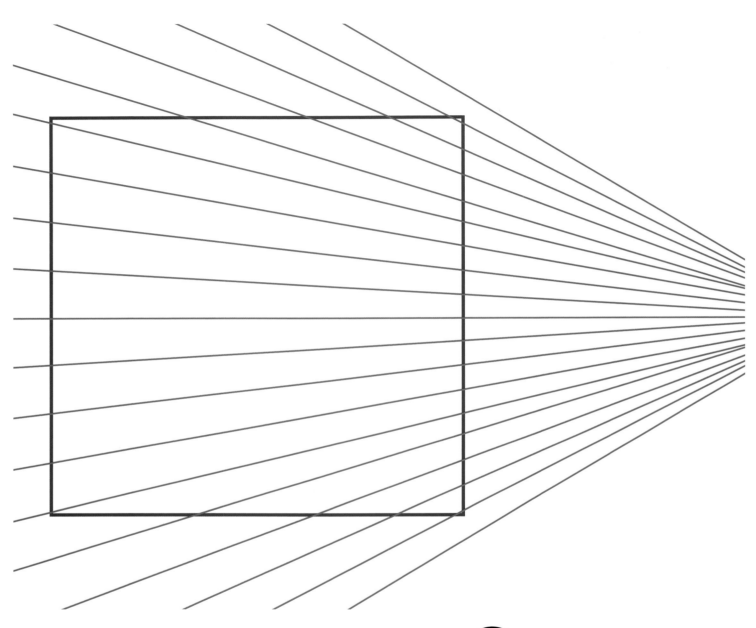

126 Orbison Illusion: Does this square appear distorted?

127 Larger within Smaller: What is the impossibility that is depicted in this drawing by Swedish artist Oscar Reutersvärd?

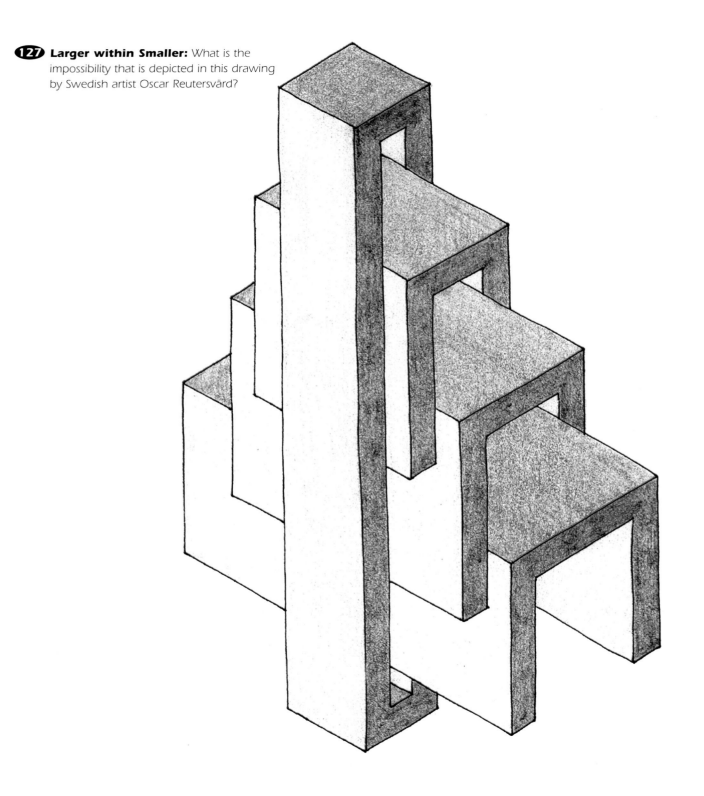

128 **Illusory wedges:** Do you perceive wedges?

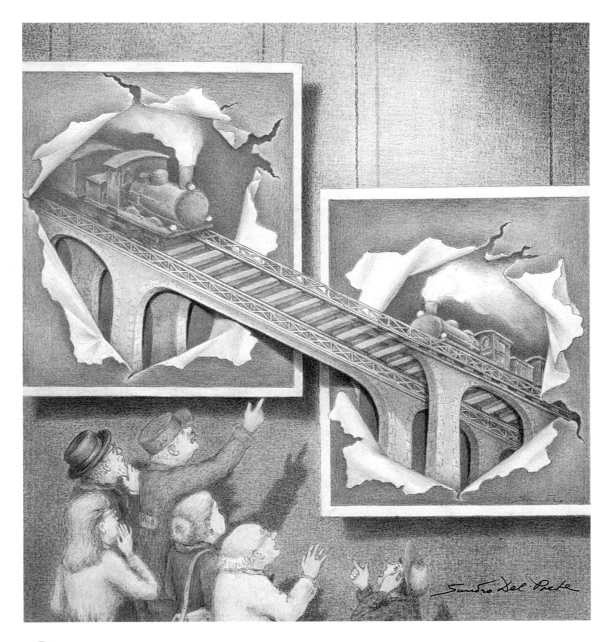

129 Incident on a Railway Bridge:
Are these trains going to collide?

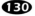 **130 Two for the Price of One!**
There are two cars here! Can
you find both of them?

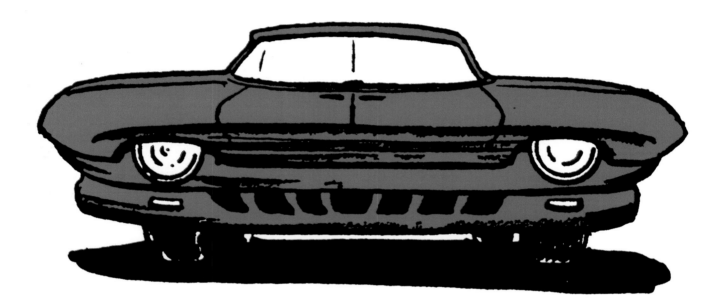

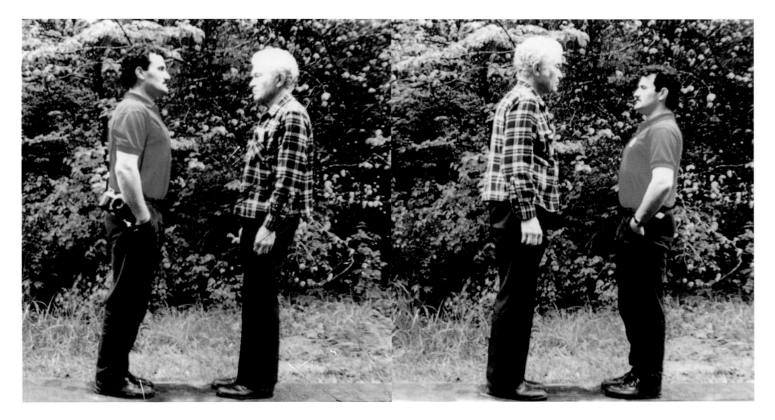

131 **The Plank Illusion.** Here are two men standing on a level plank. The men are the same height in the picture on the left, but on the right, the man in the red shirt is smaller. All they did was change places! This illusion is known as the plank illusion and is found in many tourist attractions.

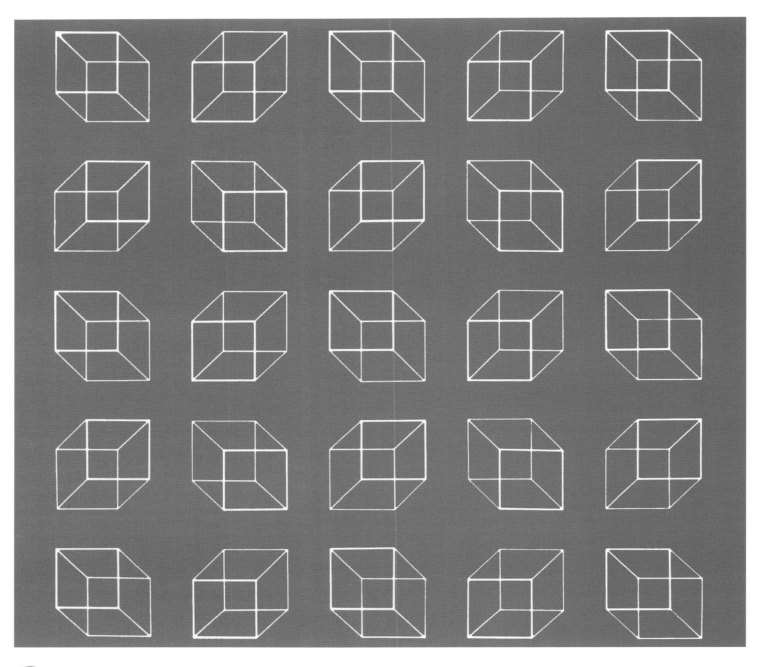

132 **Necker Cube Grouping Illusion:** Can you make all these cubes "flip-flop" at once? Can you flip-flop only one cube while looking at the entire image?

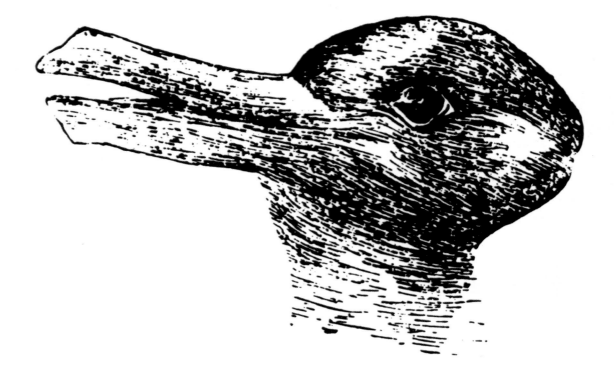

133 Duck/rabbit:
Do you perceive a rabbit or a duck?

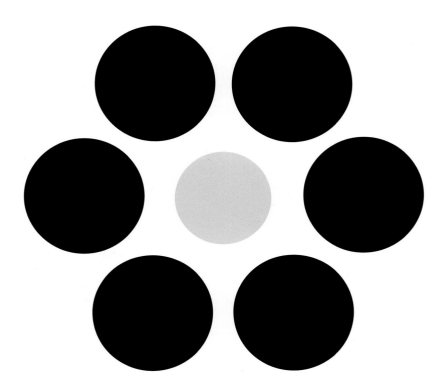

134 **Ebbinghouse Illusion:**
Do the inner circles appear to be different in size?

 Impossible Stairway:
Can you go up any levels
when you climb this set
of stairs?

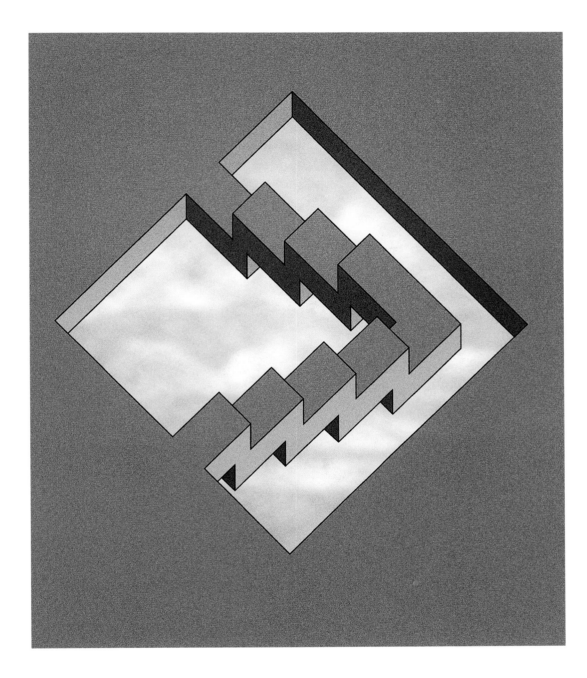

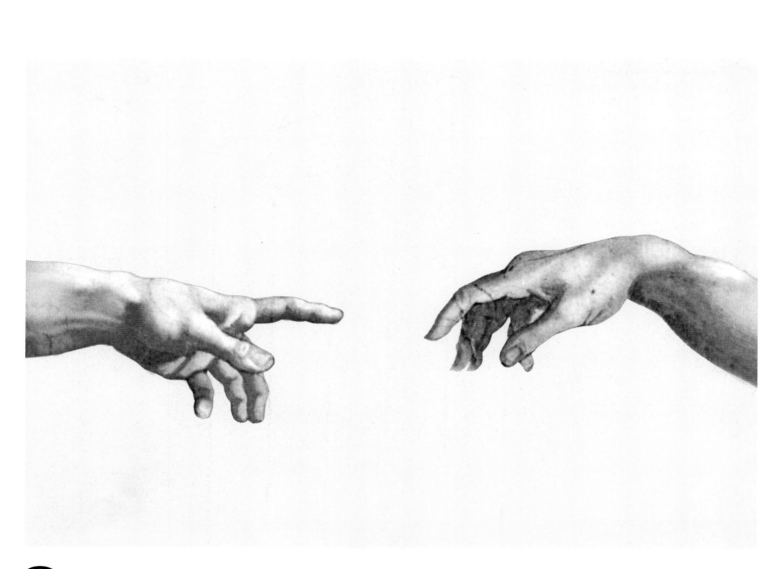

136 **It's a Miracle!** Look at this illustration with both eyes and bring it slowly to your face. The hands will touch!

137 Impossible Fork:

How many prongs can you count? Cover up each half and you will find that each end is perfectly possible, but when you uncover the two possible halves you will end up with an impossible figure. No one knows who first created this famous impossible figure, which started appearing in various publications during the year 1964.

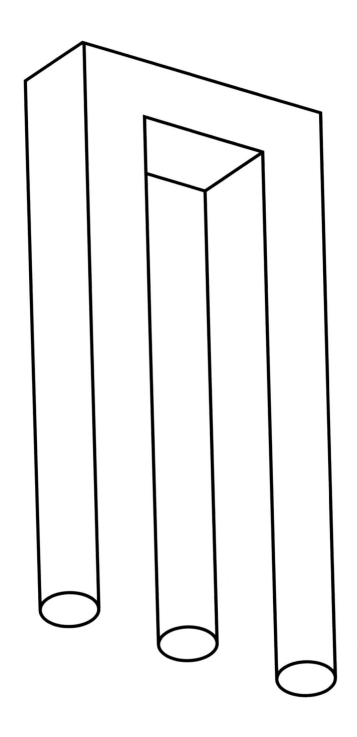

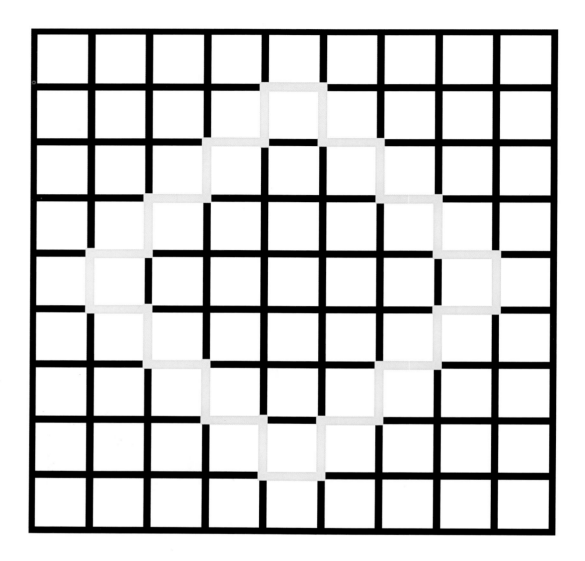

138 **Van Tuiji Illusion:** Do the inside squares of the bounded blue lines appear to have a faint bluish tint?

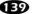 **Natural camouflage.** Can you find the American Bittern and its nest hiding in the swamp?

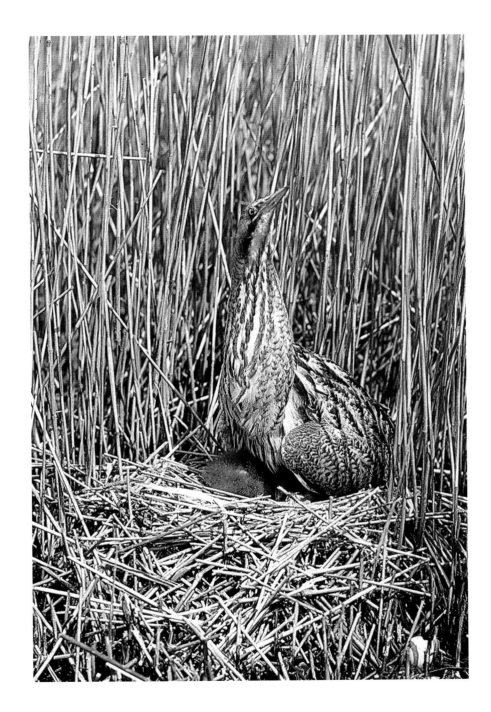

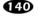 **Mach Illusion:** This is a fun illusion. Fold a piece of white paper as shown. Lay it down on the table and view it with only one eye from a distance above. Because of contradictory depth cues the paper will "invert." You should see the paper appear to stand upright. If you can hold this image stable and move from side to side the paper will appear to follow you. It should also change in brightness.

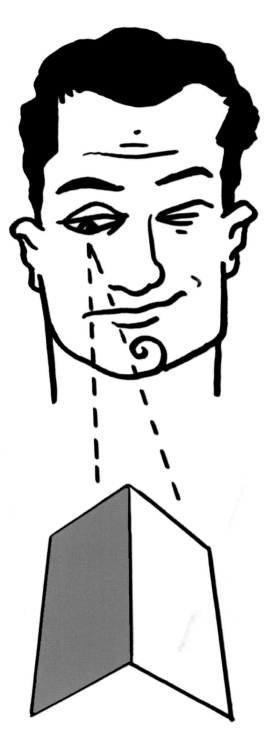

 Tricked You: Is the red square larger than the blue square or does it just appear that way? Do the horizontal lines appear to be crooked, or are they really straight?

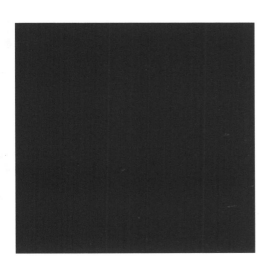

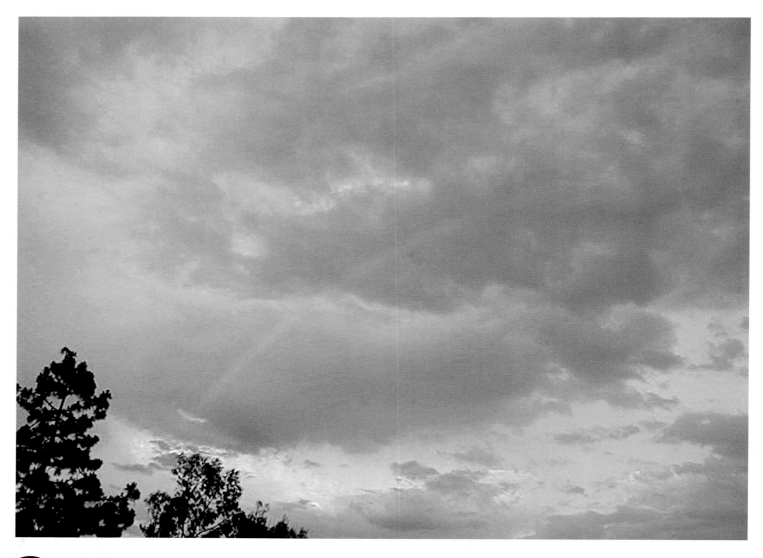

142 Nature's Most Beautiful Illusion: *A rainbow is surely nature's most beautiful illusion. Next time you see a rainbow, try to find the fainter secondary and tertiary bows.*

143 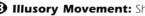 **Illusory Movement:** Shake this figure and you will see illusory movement.

Notes on Gallery IV

Arcturus II (Page 125)
Each concentric square is of uniform reflectance. The corners of each square appear brighter because two of the sides border a darker area in an effect known as simultaneous contrast. Your visual system adds the brighter corners to form straight lines in the shape of an X. "Arcturus II" is by French artist Victor Vasarely.

112. White's Illusion
The gray vertical bars are identical to each other. White's illusion is produced by a combination of two effects, grouping and simultaneous contrast. The small gray horizontal rectangles are grouped to form two large vertical gray bars. The gray bars, however, appear to be on different backgrounds. Simultaneous contrast causes the gray bar on the white background to seem darker than the gray bar on the black background.

113. Thiery's Figure
This figure will flip-flop in depth because of conflicting perspective cues. It is a variant of Thiery's figure.

115. Verbeek's Topsy-Turvy Cartoon
Gustave Verbeek published a wonderful topsy-turvy cartoon in The Sunday New York Herald in 1900. Although restricted to the normal six-panel comic strip format of his time, Verbeek was not content with this and decided to have twelve panels with no increase in space. This was achieved by having the story continue by turning the comic strip upside down. This is one illustration from his set of comical characters.

116. Chess set
The chessboard is entirely flat, but it uses deceptive shading and coloring to give the illusion that it is not flat. Bruno Ernst constructed this chess set.

118. St. George and the Dragon
The hair of the large profile defines the battle. Swiss artist Sandro Del Prete created this wonderful ambiguous illusion.

119. E Puzzle
It forms the letter E with illusory contours.

120. Muscular Aftereffect
This is a muscular aftereffect. It is similar to the experience that some people have when exiting a long escalator.

121. Minimum Visible
Some of the dots are very slightly larger than the other dots. In those areas there is more black. Seen from a distance, the slightly blacker areas can be grouped to form the image of a face.

122. Hering Figure
They are perfectly straight and parallel. This classic illusion was discovered by the 19th century German physiologist Ewald Hering.

123. Glee turns Glum
Created by Roger Shepard

124. Neptune
The fish, dolphins and plants form the outline of Neptune. This is a very nice example of an illusion that flip-flops in meaning. The drawing is by Swiss artist Sandro Del Prete.

126. Orbison Illusion
This is really a perfect square; however, radiating lines can distort one's perception of lines and shapes. Although this illusion is known as the Orbison illusion, it is a variation of the Hering illusion.

127. Larger within Smaller
There are larger pieces fitting within smaller ones!

128. Illusory wedges
The wedges are illusory. This is another variation on the twisted cord illusion by Japanese op artist and vision scientist Akiyoshi Kitaoka.

129. Incident on a Railway Bridge
How can the trains collide in a drawing! This is another fun impossible scene by Swiss artist Sandro Del Prete.

130. Two for the Price of One!
One car is on top of the other car.

131. The Plank Illusion
The plank is absolutely level and the camera position and controls are the same for both exposures. It is a misleading sloping background that causes this illusion augmented by the fact that the camera is slightly off-center

132. Necker Cube Grouping Illusion
You should be able to "reverse" all the cubes, because your visual system tends to group like items together. It is much more difficult to "flip-flop" a single cube when looking at the entire set of cubes.

133. Duck/rabbit
Both interpretations are possible in this classic illusion. It was created by psychologist Joseph Jastrow around 1900.

134. Ebbinghouse Illusion
The inner circles are identical in size. When larger circles surround the middle circle, it appears smaller than the circle surrounded by dots. This is known as the Ebbinghouse or Titchner illusion.

135. Impossible Stairway
You will always remain at the same level when you climb this set of stairs. Swedish artist Oscar Reutersvärd, who is generally regarded as the "father of impossible figures", created this impossible figure.

137. Impossible Fork
When you look at this figure, you first calculate contours or outlines, and from this you try to perceive the boundary of the shape. Your visual system's confusion occurs because several contours of this figure are ambiguous. For example, this figure makes use of the fact that a cylinder can be represented by a pair of lines, while a rectangular bar requires three lines. The illusion is contructed by completing each pair of lines to make a cylinder at one end, and each triplet to make a square bar at the other end.

This ambiguity makes the figure violate another basic distinction, that between flat and curved surfaces, where a flat strip twists into a cylindrical surface. The figure, furthermore, gives contradictory cues for the depth estimation for the position of the middle prong. And finally, there is a counting paradox associated with the figure – two prongs into three prongs.

138. Van Tuiji Illusion
All the squares bounded by the blue lines are absolutely white. Vision scientist Van Tuiji discovered this example of neon color spreading in 1975.

139. Natural camouflage
This is an example of a natural illusion camouflage. The Bittern even mimics the movement of the reeds in the background to avoid being spotted.

140. Mach Illusion
The card follows you because of a reversed motion parallax. Motion parallax is what you observe when you look outside the window of a moving car. Objects that are close to you move quickly and in the opposite direction to your movement. Objects that are further away appear to move slower and also in the opposite direction. In the case of this illusion, the nearest and farthest points are reversed, which causes a reverse in the motion parallax. This illusion was discovered by the physicist Ernst Mach in the 19th century and is known as the Mach illusion.

141. Tricked You
The lines are bent and the red square is bigger. If you answered that they were the same size and that the horizontal lines were straight, you were tricked, because there is no illusion. However, if you were tricked, you were fooled into an illusion without an illusion! This, of course, is an illusion!

144. Hogarth
There are over twenty mistakes of perspective in this 17th century illustration by William Hogarth.

144 **Hogarth:** How many mistakes of perspective can you find?

Further Reading

Block, J. Richard and Yuker, H., *Can You Believe Your Eyes?*
Gardner Press, Inc., 1989

Cobb, Vicki, *How to Really Fool Yourself: Illusions for all Your Senses*,
John Wiley and Sons, Inc., 1999

*Coren, Stanley and Girgus, J. S., *Seeing is Deceiving: The
Psychology of Visual Illusions*, Erlbaum Press, 1978

Ernst, Bruno, *The Eye Beguiled: Optical Illusions*,
Benedikt Taschen, 1992

*Frisby, John, *Seeing: Illusion, Brain and Mind*,
Oxford University Press, 1980

Goldstein, E. Bruce, *Sensation and Perception: Fourth edition*,
Wadsworth, 1997

Gregory, Richard, *Eye and Brain: Fifth Edition*,
Princeton University Press, 1997

Gregory, Richard and Gombrich, E. H., *Illusion in Nature and Art*,
Gerald Duckworth, 1980

Hoffman, Donald, *Visual Intelligence: How We Create What We See*,
W. W. Norton & Company, 1998

*Palmer, Stephen, *Vision Science: Photons to Phenomenology*,
The MIT Press, 1999

*Robinson, J. O., *The Psychology of Visual Illusion*,
Dover Publications, 1998

Rock, Irvin, *Perception*, Scientific American Library, 1984

Rodgers, Nigel, *Incredible Optical Illusions*, Barnes and Noble, 1998

Shepard, Roger, *Mind Sights*, W. H. Freeman and Company, 1990

*Spillman, Lothar and John Werner, *Visual Perception: The
Neurophysiological Foundations*, Academic Press, 1990

*Advanced reading

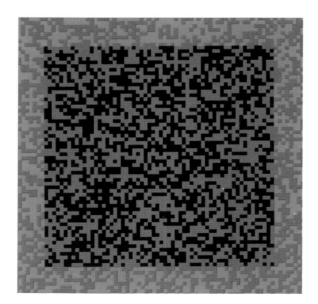